PAINTER'S QUICK REFERENCE

Birds & Butterflies

EDITORS OF NORTH LIGHT BOOKS

NORTH LIGHT BOOKS
CINCINNATI, OHIO
www.mycraftivity.com

Distributed in Canada by Fraser Direct
100 Armstrong Avenue
Georgetown, ON, Canada L7G5S4

Distributed in the U.K. and Europe by David & Charles
Brunel House, Newton Abbot, Devon TQ12 4PU,
England Tel: (+44) 1626 323200,
Fax: (+44) 1626 323319
Email: postmaster@davidandcharles.co.uk

Distributed in Australia by Capricorn Link
P.O. Box 704, Windsor, NSW 2756 Australia

Other fine North Light Books are available from your local bookstore, art supply store or direct from the publisher.

12 11 10 09 08 5 4 3 2 1

Library of Congress Cataloging-in-Publication Data
Painter's quick reference : birds & butterflies / editors of North Light Books.
 p. cm.
 Includes index.
 ISBN-13: 978-1-60061-031-8 (pbk. : alk. paper)
 1. Birds in art. 2. Butterflies in art. 3. Painting--Technique. I. North Light Books (Firm) II. Title: Birds & butterflies.
 ND1380.P33 2008
 751.45'4328--dc22
 2008008598

Editor: Jacqueline Musser
Production Coordinator: Greg Nock

www.fwpublications.com

Metric Conversion Chart

to convert	to	multiply
Inches	Centimeters	2.54
Centimeters	Inches	0.4
Feet	Centimeters	30.5
Centimeters	Feet	0.03
Yards	Meters	0.9
Meters	Yards	1.1
Sq. Inches	Sq. Centimeters	6.45
Sq. Centimeters	Sq. Inches	0.16
Sq. Feet	Sq. Meters	0.09
Sq. Meters	Sq. Feet	10.8
Sq. Yards	Sq. Meters	0.8
Sq. Meters	Sq. Yards	1.2
Pounds	Kilograms	0.45
Kilograms	Pounds	2.2
Ounces	Grams	28.3
Grams	Ounces	0.035

Introduction

WHEN YOU'RE IN A HURRY FOR PAINTING HELP, HERE'S THE BOOK TO COME TO FOR IDEAS, INSTRUCTIONS AND INSPIRATION.

The colorful markings of butterflies and the bright wings of birds add sparks of life and personality to gardens and paintings alike. Here, eleven artists share their painting secrets and expertise in more than forty clear step-by-step demonstrations and valuable "artist's comments" insights that are sure to give you exactly what you need. Refresh your skills by reacquainting yourself with fundamental painting techniques, or indulge your adventurous side by exploring new ones. And with painting instruction for four major mediums—acrylics, watercolor, oil and colored pencil—you not only gain advice and tips for your primary medium, but for other mediums you may want to try.

Do you want to learn how to render the graceful wings of a silvery blue butterfly? The colorful markings of a peacock and red macaw? The delicate details on a blue jay feather? The steps are easier than you think, and they are all within these pages. Simply turn the page, and start painting!

Table of Contents

INTRODUCTION 3

BUTTERFLIES
Giant Swallowtail 1 6
Giant Swallowtail 2 10
Giant Swallowtail 3 14
Mourning Cloak 16
Heliconius Anderida 20
Common Blue 24
Silvery Blue 26
Alfalfa Butterfly 28
Cabbage Butterfly 30
Southern Dogface 32
Morpho 34
Peacock Butterfly 38
Painted Lady 42

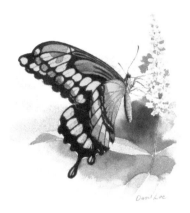

MOTHS
Geometrid 46
Noctuid 48
Sphinx Moth 50

SONGBIRDS
Goldfinch 1 54
Goldfinch 2 58
Hummingbird 1 60
Hummingbird 2 64
Blue-Throated Hummingbird 68
Bluebird 71
Cardinal 74
Blue Jay 78
Mockingbird 80
Painted Bunting 82
House Sparrow 1 84
House Sparrow 2 86
Wren 88
Black-Capped Chickadee 90

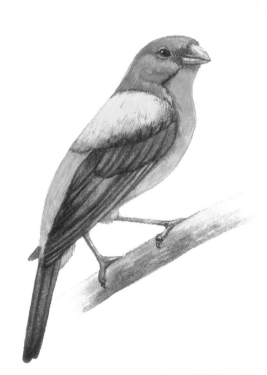

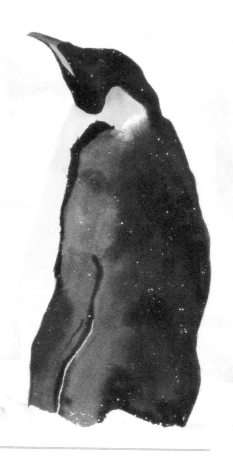

WATERBIRDS
 Mallard Duck 92
 Egret 96
 Seagull 100
 Emperor Penguin 104

EXOTIC BIRDS
 Cockatiel 106
 Red Macaw 110
 Peacock 112

DETAILS
 Robin's Nest 116
 Wood Thrush Feather 118
 Blue Jay Feather 119
 Evening Grosbeak Feather 120
 Green Jay Feather 121
 Four Types of Eggs 122

ABOUT THE ARTISTS 124

RESOURCES 126

INDEX 127

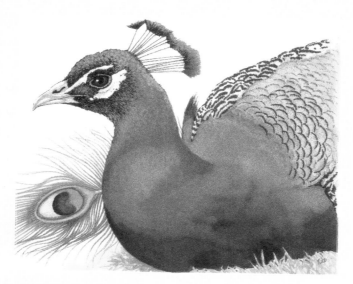

Butterflies

Butterfly species are identified by their distinctive markings. Their wings hold some of the most colorful and intriguing patterns in nature.

Giant Swallowtail 1

GARY GREENE

MEDIUM: *Colored pencil*

COLORS: **Sanford Prismacolor:** *Jasmine • Black • Dark Brown • Cream • Pumpkin Orange • Pale Vermilion • White • Sunburst Yellow • Blue Violet Lake • Blue Slate • Sienna Brown • Goldenrod •* **Sanford Prismacolor Verithin:** *Black • Dark Brown •* **Faber-Castell Polychromos:** *Light Yellow Ochre*

BRUSHES: *Small, round watercolor brush*

OTHER SUPPLIES: *Three-ply Strathmore Vellum Bristol (regular surface) • electric pencil sharpener • Sakura electric eraser with white vinyl eraser strip • Prismacolor Colorless Blender • Bestine rubber cement thinner • Prismacolor Tuffilm Final Fixative (matte finish)*

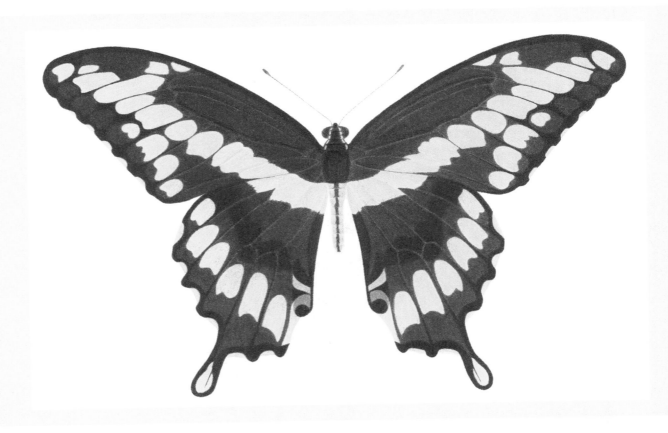

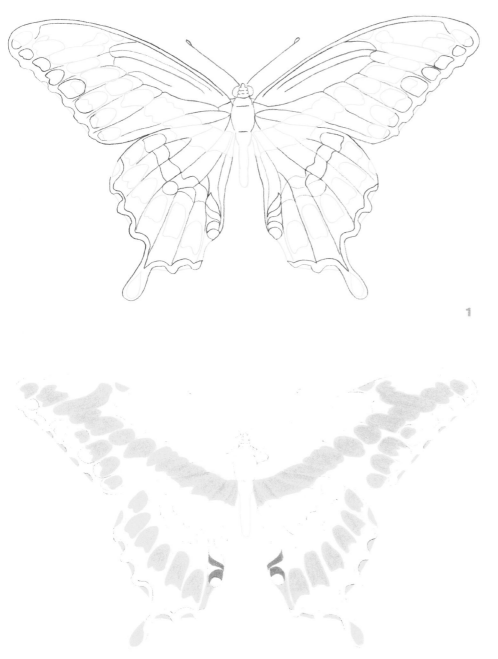

1 Draw the Layout

Draw the layout lines with Jasmine, Sunburst Yellow, Black and Dark Brown.

2 Paint the Light Wing Markings

For the yellow wing markings: Lightly apply (Polychromos) Light Yellow Ochre and Jasmine. Using slightly more pressure, apply Cream. Reapply the three colors until the entire area is covered with pigment, leaving no paper showing through.

For the red eyespots: Lightly apply Pumpkin Orange and Pale Vermilion. Using slightly more pressure, apply White. Reapply Pumpkin Orange and Pale Vermilion until the entire area is covered with pigment, leaving no paper showing through.

For the blue markings: Lightly apply Blue Violet Lake and Blue Slate. Using slightly more pressure, apply White. Re-apply Blue Violet Lake and Blue Slate until the entire area is covered with pigment, leaving no paper showing through.

artist's comment

Keep your pencil points extremely sharp at all times. Apply the colors in the sequence described. The lines shown in the example layout are heavy for clarity only. Always draw your actual layout lines as lightly as possible.

Giant Swallowtail 1

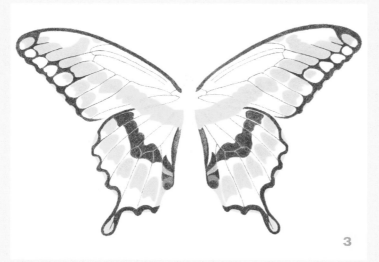

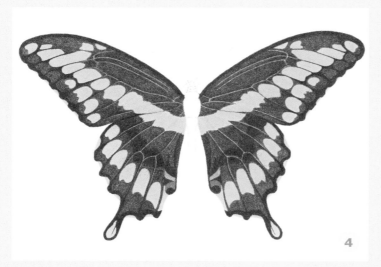

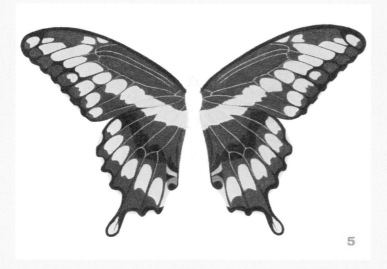

3 Paint the Black Wing Markings
Lightly apply Black to the wings. Do not cover the paper surface entirely. Carefully draw vein lines with a Black Verithin pencil.

4 Paint the Wings Brown
Apply Dark Brown to the remaining wing areas and over the black wing markings. Leave a line of blank white paper parallel to the dark vein lines free of color.

5 Paint the Second Brown Layer
Apply Sienna Brown over the Dark Brown wing areas.

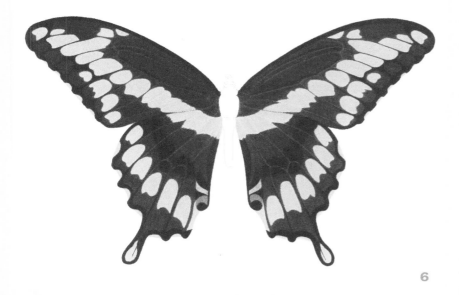

6

6 Finish the Wings

Reapply Dark Brown over the black and brown wing areas until the paper surface is completely covered. Lightly apply Dark Brown over the uncolored vein lines and then blend with Prismacolor Colorless Blender. Sharpen the edges with Dark Brown or (Verithin) Black.

7 Paint the Body, Eyes and Antennae

Lightly apply (Polychromos) Light Yellow Ochre and Jasmine to the entire body. Do not apply color to the eyes or antennae. With a small, round watercolor brush, apply Bestine rubber cement thinner to the body, being careful not to touch the adjacent wing areas. Apply Black, Dark Brown and Goldenrod to the body.

Lightly paint the eyes with Black, allowing some paper surface to show through. Carefully draw antennae with (Verithins) Dark Brown and Black. Finish with Prismacolor Tuffilm Final Fixative (matte finish).

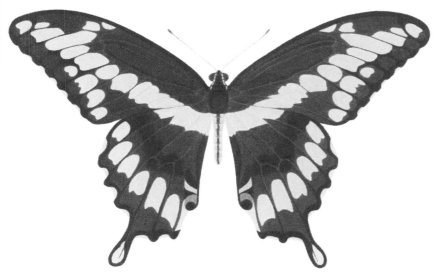

7

Giant Swallowtail 2

DAVID LEE

MEDIUM: *Watercolor*

COLORS: **Winsor & Newton Artists' Water Colour:** *Cerulean Blue • French Ultramarine • Prussian Blue • Sap Green • Vandyke Brown • Yellow Ochre • Red*

BRUSHES: **Winsor & Newton:** *no. 0 sable short liner •* **Grumbacher:** *nos. 2, 6, 8 and 12 sable rounds • no. 5 sable script liner*

OTHER SUPPLIES: *140-lb. (300gsm) cold-pressed Arches watercolor paper • masking fluid • Faber-Castell nos. 2B and HB pencils • Staedtler Mars Plastic eraser*

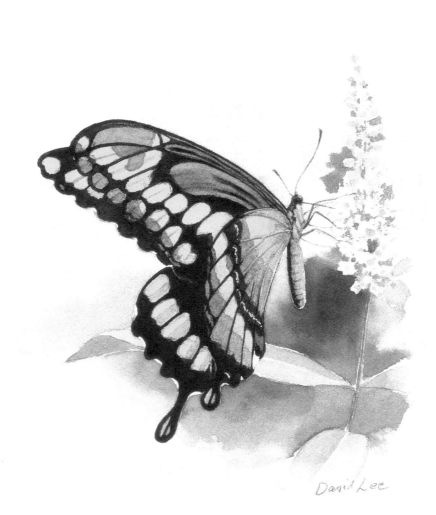

David Lee

1 Create the Basic Sketch

Use no. 2B and HB pencils to draw a detailed sketch of the butterfly with a simple background based on collected reference materials.

2 Apply Masking Fluid and Yellow Ochre Wash

Using a thin stick or small brush, apply masking fluid to preserve small white areas that might be difficult to paint around. After the masking fluid dries, apply Yellow Ochre with a no. 8 sable round brush to the entire butterfly. Glaze with two or three thin layers of the same color to enrich it.

artist's comment

Butterflies are fun to watch and paint because of their colorful and interestingly shaped wings. Here are a couple of technical tips for reference:

- To protect your brush from damage from the masking fluid, wet the brush with liquid soap first. Clean thoroughly immediately after use.
- To enrich a color by glazing, be sure the surface is completely dry between each application of thin layers. A hair dryer works well.
- To preserve and protect your watercolor paper, sketch your composition on regular paper first. Once you're happy with the design, transfer it to watercolor paper using tracing paper.

Giant Swallowtail 2

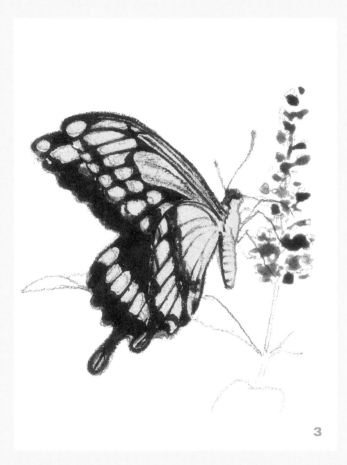

3

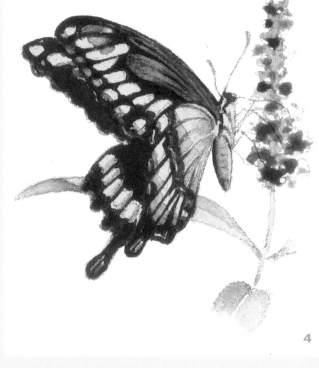

4

3 Add Black to Wings

Create black by mixing approximately 60 percent French Ultramarine + 40 percent Van Dyke Brown. Use this color with a no. 0 short liner brush to paint fine lines and with nos. 2 and 6 sable round brushes to paint the black patterns on the butterfly wings and body.

4 Detail Wings and Plant

Refine the wings with Van Dyke Brown and add a touch of red on the lower wing as shown. Paint the background plant with Sap Green mixed with a little Yellow Ochre and Cerulean Blue.

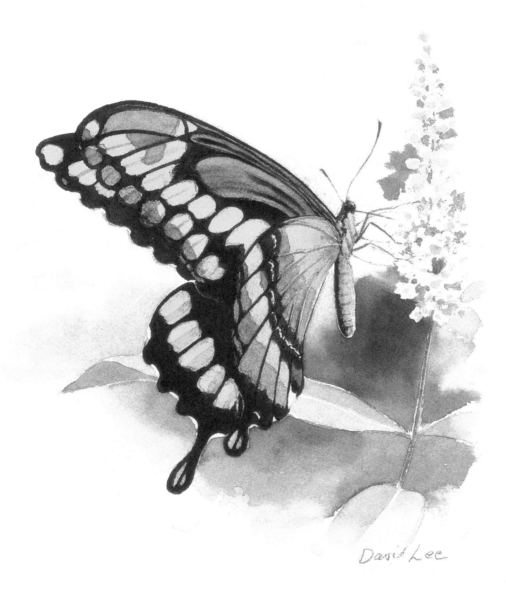

David Lee

5

5 Paint Background and Final Details

Paint the background with complementary colors of Sap Green and Prussian Blue. Use nos. 8 and 12 sable round brushes loosely for the background and a no. 5 sable script liner for the flower stem. Remove the masking fluid after the watercolor dries. Finish the flowers with Yellow Ochre and Sap Green. Add final touches for butterfly's details, the six legs and antennae with small brushes as desired.

Giant Swallowtail 3

CINDY AGAN

MEDIUM: *Watercolor*

COLORS: **Winsor & Newton Artists' Water Colour:** *Turner's Yellow* • *Yellow Ochre* • *Sepia* • *Mars Black* • **Schmincke:** *Ultramarine Blue* • *Translucent Orange*

BRUSHES: **Jack Richeson 9000 Series:** *nos. 2 and 4 rounds*

OTHER SUPPLIES: *140-lb. (300gsm) cold-pressed Arches watercolor paper, 8" × 10" (20cm × 25cm)* • *no. 3H pencil*

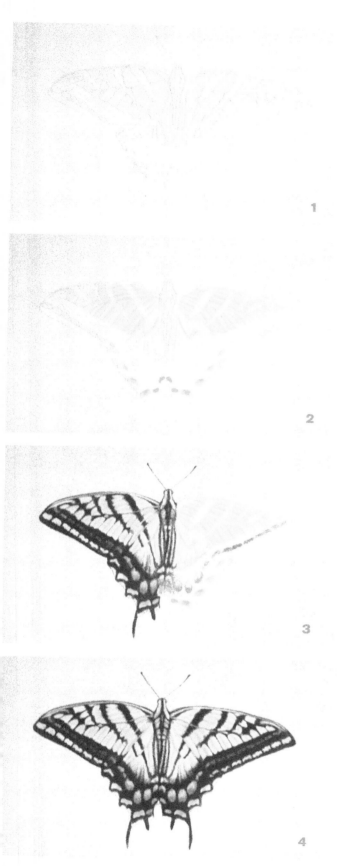

1 Paint the Base Color

I think you will find painting this giant swallowtail as fun and simple as coloring with crayons in a coloring book! Using a no. 4 round, begin with a very pale glaze of Turner's Yellow on the markings indicated and let dry completely. Don't worry about going "out of the lines" as this area will be painted black later.

2 Deepen the Value

With a no. 4 round, apply another glaze of Turner's Yellow to the top wings and let dry. Switch to a no. 2 round and thinned Yellow Ochre to lightly drybrush thin lines between each vein. Imagine there is a soft light source from above, and paint subtle cast shadows on the side of the wings that are shaded. Drybrush Translucent Orange on the marking on the lower wings. When dry, add a light glaze of Turner's Yellow over the orange markings.

3 Add Black and Blue

Continue glazing and drybrushing with Turner's Yellow and Yellow Ochre to build the color intensity. Drybrush the row of markings on the lower wings with Sepia and a no. 2 round. Next, thin Ultramarine Blue until it's a pale blue, glaze over the final ten markings and let dry. On the bottom half of these light-blue markings, stipple tiny dots with a darker concentrate of Ultramarine Blue using a no. 2 round. With all of the colors in place, paint around them with Mars Black to make them stand out.

4 Add Black for Impact and Final Touches

Notice that the transition around some of the markings goes from black to color softly and gradually, while other areas have a hard edge. Where the black paint overlaps into the colored markings, softly blend using short, quick strokes.

Continue to build up the Mars Black until the color is dark and rich. Edges that become too harsh can be softened with a clean damp brush. When the black paint is completely dry, brighten any colored markings that have "paled" by glazing additional color where needed.

artist's comment

Drybrushing uses very little water and is perfect for painting fine details. Simply load your brush with color, blot the excess moisture on a towel and paint with precision and control. When painting in watercolor I use a white terry cloth towel to blot my brush instead of paper towels to save time and money. Simply wash the towel separately in the washing machine when you're finished.

Mourning Cloak

GARY GREENE

MEDIUM: *Colored Pencil*

COLORS: **Sanford Prismacolor:** *Beige • Cream • Warm Grey 20 percent • Warm Grey 70 percent • Warm Grey 90 percent • Lilac • Greyed Lavender • Tuscan Red • Black Raspberry • Black*

BRUSHES: *Small, round watercolor brush*

OTHER SUPPLIES: *Three-ply Strathmore Vellum Bristol (regular surface) • electric pencil sharpener • Sakura electric eraser with white vinyl eraser strip • Prismacolor Tuffilm Colorless Blender • Bestine rubber cement thinner • Prismacolor Tuffilm Final Fixative (matte finish) • cotton swabs*

1

1 Draw the Layout
Draw the layout lines with Beige, Warm Grey 20 percent, Warm Grey 70 percent and Lilac.

2 Underpaint the Wings
Apply Beige and Cream to the wings using light, circular strokes.

2

artist's comment

Keep your pencil points extremely sharp at all times. Apply the colors in the sequence described. The lines shown in the example layout are heavy for clarity only. Always draw your actual layout lines as lightly as possible.

Mourning Cloak

3 Blend the Under-
painting
Using cotton swabs, blend
Beige and Cream with Bes-
tine rubber cement thinner.
When a cotton swab dries,
switch to a new one.

4 Add Dark Values to the
Wings
Apply Lilac and Greyed
Lavender to the lavender
wing spots. Apply Warm
Grey 90 percent and Warm
Grey 70 percent to the dark-
gray bands surrounding the
lavender wing spots. Apply
Warm Grey 70 percent to
establish darker wing values.

3

4

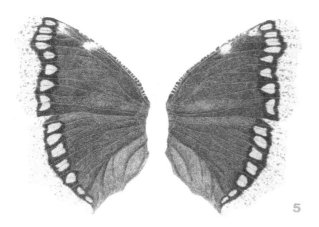

5 Paint the Wings

Redraw veins lightly with Warm Grey 90 percent, except those along the edges. Apply Tuscan Red and Black Raspberry to the wings. Leave a line parallel to the dark vein lines uncolored. Lightly apply Tuscan Red to lessen the vein highlight lines. Using short, circular strokes paint speckles on the wing edges with Tuscan Red and Black Raspberry.

5

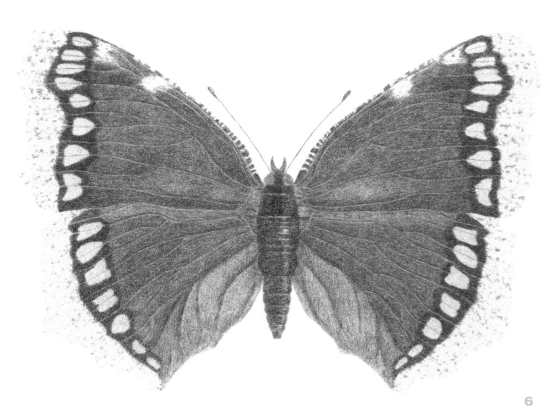

6

6 Paint the Body and Antennae

Draw the body segment lines with Warm Grey 90 percent, leaving a highlight line underneath. Apply Black, Warm Grey 90 percent, Warm Grey 70 percent, Tuscan Red and Black Raspberry to the body and compound eyes. Carefully draw antennae with Warm Grey 90 percent and Tuscan Red. Finish with Prismacolor Tuffilm Final Fixative (matte finish).

Heliconius Anderida

David Lee

Medium: *Watercolor*

Colors: ***Winsor & Newton Artists' Water Colour:*** *Alizarin Crimson • Burnt Sienna • Cerulean Blue • French Ultramarine • Prussian Blue • Sap Green • Vandyke Brown • Yellow Ochre*

Brushes: ***Winsor & Newton:*** *no. 0 sable short liner •* ***Grumbacher:*** *nos. 2, 6, 8 and 12 sable round • no. : sable script liner*

Other Supplies: *140-lb. (300gsm) cold-pressed Arches watercolor paper • masking fluid • Faber-Castell nos. 2B and HB pencils • Staedtler Mars Plastic eraser*

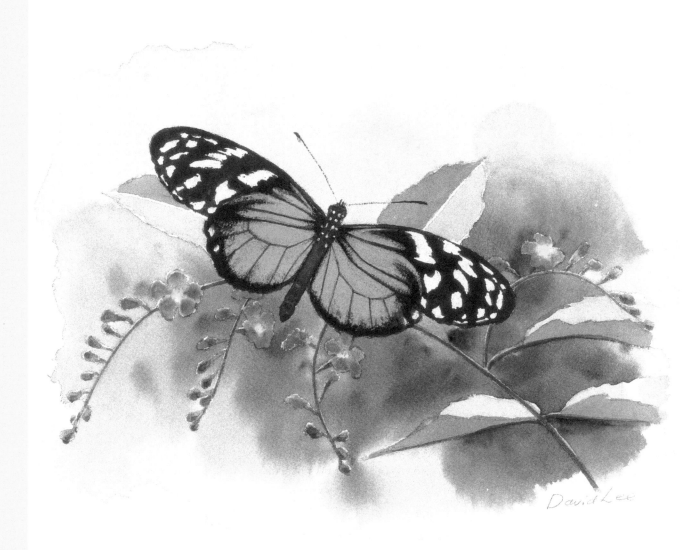

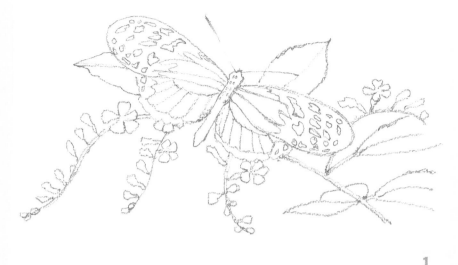

1

1 Draw the Basic Sketch

Use nos. 2B and HB pencils to draw a detailed sketch of the butterfly with simple background flowers and leaves based on collected reference materials.

2 Apply Masking Fluid and Orange Wash

Use a thin stick or small brush to apply masking fluid to preserve small white dots, patterns and small background flowers and stems that might be difficult to paint around.

When the masking fluid dries, apply an orange mixture (60 percent Cadmium Red and 40 percent yellow) with a no. 8 sable round brush to the lower butterfly wings. Glaze with an additional thin layer of the same mixture to enrich the color as necessary.

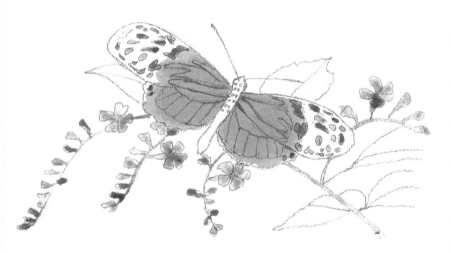

2

artist's comment

To protect your brush from damage from the masking fluid, wet the brush with liquid soap first. Clean thoroughly immediately after use.

To enrich a color by glazing, be sure the surface is completely dry between each application of thin layers. A hair dryer works well.

To preserve and protect your watercolor paper, sketch your composition on regular paper first. Once you're happy with the design, transfer it to watercolor paper using tracing paper.

Heliconius Anderida

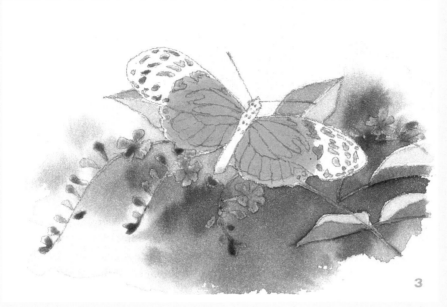

3 Paint Leaves and Background
Paint the leaves with Sap Green with touches of Yellow Ochre and Cerulean Blue using nos. 6 and 8 sable rounds. Then paint the background loosely with nos. 8 and 12 sable rounds using colors that are complementary to the butterfly—Prussian Blue and Sap Green. Drop in dark Prussian Blue in some areas to create an interesting composition.

4 Paint Black Areas
Mix black (60 percent French Ultramarine and 40 percent Van Dyke Brown). Use a no. 0 sable short liner to create fine lines and antenna. Use the nos. 2 and 6 sable rounds for larger black areas of the butterfly.

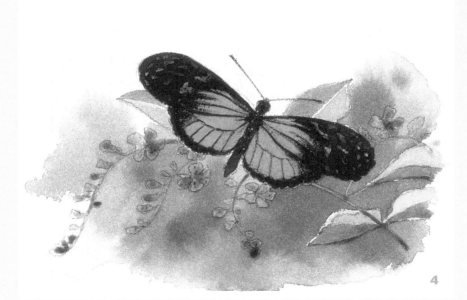

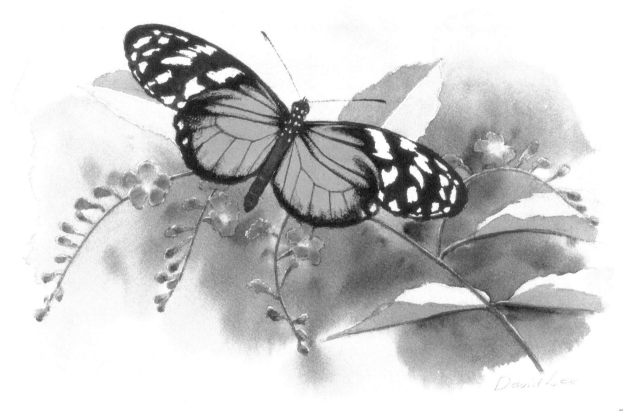

5

5 Paint Flowers and Leaves

Remove the masking fluid from the preserved white areas. Touch up and smooth out the butterfly patterns. With a no. 6 sable round, use a purple color (a mixture of mauve and Alizarin Crimson) for the flowers and tips of the buds, and green (Sap Green + Yellow Ochre and Sap Green + Burnt Sienna) for the buds. Use dark green with a no. 5 sable script liner for the flower stem. Remove pencil lines if you prefer.

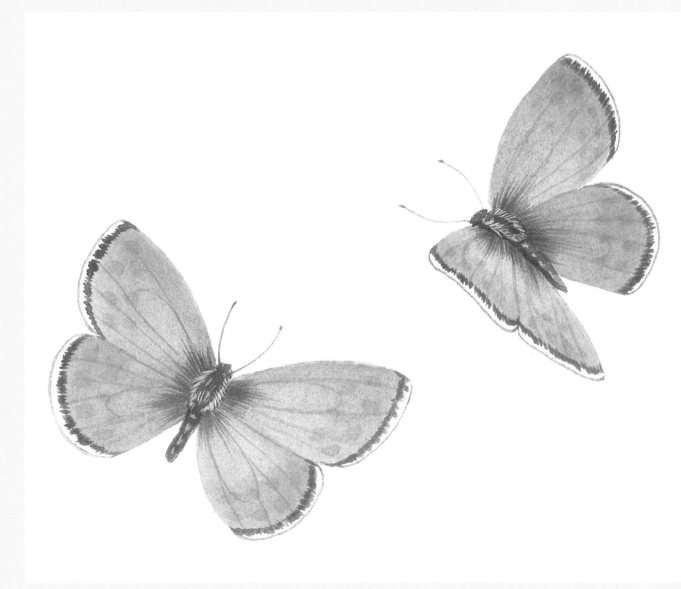

Common Blue

JANE MADAY

MEDIUM: *Acrylics*

COLORS: **Plaid FolkArt Artist's Pigments:** *Cobalt Blue • Payne's Gray • Titanium White • Butler Magenta Raw Sienna • Raw Umber*

BRUSHES: **Silver Brush Ultra Mini Designer Rounds:** *nos. 2, 4 and 6 (You will need to use smaller rounds you use another brand.)*

OTHER SUPPLIES: *Cold-pressed Canson Montval watercolor paper • Masterson Sta-Wet Palette • water con tainer • masking fluid (optional)*

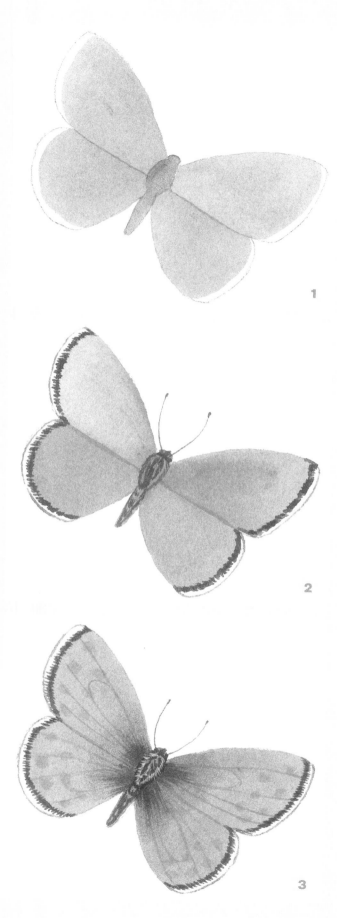

1 Basecoat the Wings

Basecoat the wings with thinned Cobalt Blue, leaving a white rim at the edge of the wings. Basecoat the body with thinned Payne's Gray using a no. 6 round.

2 Glaze Wings and Detail Body

Glaze thinned Butler Magenta across the wings. When dry, paint the brown edges with Raw Umber and the no. 4 round. Detail the body with Payne's Gray, using the paint with a creamy consistency. Switch to the no. 2 round to paint the antennae.

3 Detail Wings and Body

Paint a thin wash of Raw Sienna across the wings using the no. 4 round. Add thin Payne's Gray lines radiating out from the body with the no. 2 round. Add a few Titanium White hairs to the body. Paint subtle spots and delicate veins on the wings with Cobalt Blue + Butler Magenta (1: touch), still using the no. 2 round.

artist's comment

This butterfly is commonly found in Europe. I've painted the male of the species. An American version, the Karner blue, is similar in appearance to the common blue, but rarer (the Karner blue is endangered). This butterfly is one of my favorites to add to paintings that need a spot of color and life.

Dilute all the paint for this project with water and paint in a washy, watercolor manner.

"Glaze" in this project means to paint a thin wash of one color over another dry color. Glazing produces a glowing effect that you can't get by brush-mixing the two colors on your palette.

Silvery Blue

SHERRY C. NELSON

MEDIUM: *Oils*

COLORS: **Winsor & Newton Artists' Oil Colour:** *Ivory Black • Titanium White • Raw Sienna • Raw Umber • French Ultramarine • Alizarin Crimson • Sap Green*

BRUSHES: **Sherry C. Nelson Red Sable:** *nos. 2 and 4 brights • no. 0 round*

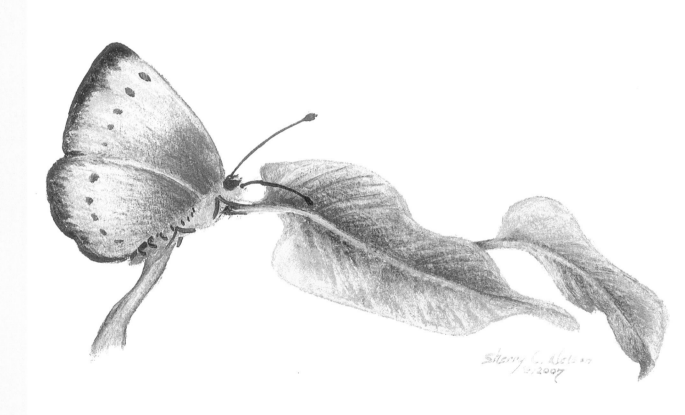

1 Base Wings and Leaves

Base the wings with a mixture of French Ultramarine + Alizarin Crimson (2:1) + Raw Sienna (to cut the intensity), using the no. 4 bright brush. Basecoat the dark area of the leaves and stem with Ivory Black + Sap Green.

2 Base Body and Detail Wing and Leaves

Base the body with the wing mixture from Step 1. Shade the wing next to the body with a dirty brush + French Ultramarine. Fill in the rest of the leaves and stem with Sap Green + Raw Sienna + Titanium White.

3 Add Highlights

Blend the blue shading where values meet. Highlight within the sections on the outer portions of both wings, and add a little highlight to the body.

Blend the leaves in the lateral growth direction using the chisel edge of the no. 4 bright for the larger leaf and the chisel edge no. 2 bright for the smaller one. Add highlights with the dirty brush + Titanium White on both leaves and in the center of the stem.

4 Add Final Details

(See finished painting on page 26.) Soften the white highlights on the wings. Add a dark margin and the tiny dots with a mixture of Ivory Black + Raw Umber. Detail the body and add antennae with the same mixture, slightly thinned and the no. 0 round brush. Blend the leaf highlights following the lateral growth direction. Accent the leaves with a little of the wing base mixture from Step 1.

artist's comment

In this demonstration, the "+" sign indicates brush-mixed colors. These mixes vary naturally and create a more realistic look than palette-knife mixes do. Continue using the same brush type and size in each area unless told to switch to a different size.

27

Alfalfa Butterfly

JANE MADAY

MEDIUM: *Acrylics*

COLORS: **Plaid FolkArt Artist's Pigments:** *Cobalt Blue • Yellow Light • Raw Umber • Yellow Ochre • Light Red Oxide • Vandyke Brown*

BRUSHES: **Silver Brush Ultra Mini Designer Rounds:** *nos. 4, 6 and 12 (You will need to use smaller round if you use another brand.)*

OTHER SUPPLIES: *Cold-pressed Canson Montval watercolor paper • Masterson Sta-Wet Palette • water container • masking fluid (optional)*

1

1 Basecoat Wings and Body

Wet the background with clean water and paint a thin wash of Cobalt Blue while the paper is still wet using a no. 12 round.

Basecoat the wings with Yellow Light, still using the no. 12 round. Thin Raw Umber with water and paint the body with the no. 6 round. Paint a thin glaze of Yellow Ochre on the wings, blending from the body outward.

2 Paint Brown Markings

If desired, protect the yellow spots at the edge of the wings with masking fluid, then paint the brown areas with thinned Raw Umber and the no. 4 round. When dry, remove the masking fluid and glaze Yellow Ochre over the yellow spots.

3 Add Final Details

Detail the body and paint the antennae with Vandyke Brown and the no. 4 round (or smaller brush if you prefer). Add the spots on the wings with Raw Umber and Light Red Oxide. Paint the wing veins with a thinned mixture of Yellow Ochre + Raw Umber (1:1) and the no. 4 (or smaller) round.

artist's comment

This butterfly is fairly common in the U.S., especially in the West and Midwest. When painting butterflies in acrylics, I like to thin the paint until it's transparent. If you use paint that's too thick, the butterfly can appear heavy and solid.

When using masking fluid, protect your brush by dipping it in a solution of one-half dishwashing liquid and one-half water before loading it with the masking fluid.

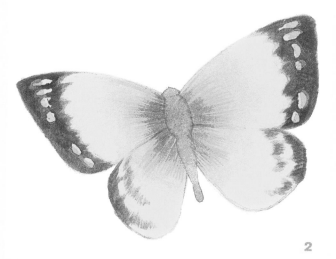

2

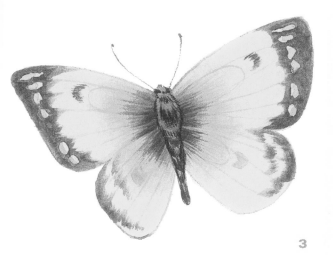

3

Cabbage Butterfly

JANE MADAY

MEDIUM: *Acrylics*

COLORS: **Plaid FolkArt Artist's Pigments:** *Cobalt Blue • Warm White • Yellow Ochre • Vandyke Brown • Raw Umber*

BRUSHES: **Silver Brush Ultra Mini Designer Rounds:** *nos. 4, 6, 12 and 14 (You will need to use smaller rounds if you use another brand.)*

OTHER SUPPLIES: *Cold-pressed Canson Montval watercolor paper • Masterson Sta-Wet Palette • water container • masking fluid (optional)*

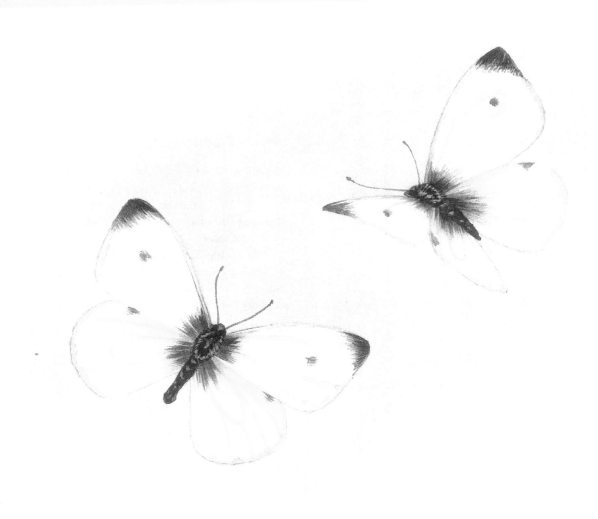

1 Basecoat Wings and Body

Wet the paper around the butterflies with clean water and the no. 14 round. Paint a wash of very thin Cobalt Blue, letting it blend out to the edges of the wet area.

Mix Warm White + Yellow Ochre (1: very slight touch) and basecoat the wings with the no. 12 round. Let dry. Basecoat the body with thinned Vandyke Brown and the no. 6 round.

2 Add Markings to Wings

Paint a thin glaze of Yellow Ochre where the wings meet using the no. 4 round brush. Let dry. Paint the dark markings on the wings with thinned Vandyke Brown and the no. 4 round brush.

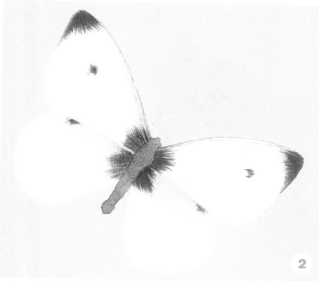

3 Add Final Details

Using the no. 4 round, paint the details on the body with slightly thicker Vandyke Brown. Add a few Warm White hairs, if desired. Mix Raw Umber + Yellow Ochre (1:1) and dilute until very thin, then paint the remaining details on the wings with the no. 4 round (or a smaller brush if you prefer). Paint the antennae using Vandyke Brown.

artist's comment

This butterfly is familiar to gardeners around the world. The cabbage butterfly makes a nice addition to your paintings as a little touch of life that fits anywhere.

Butterflies are delicate, so I use acrylic paint thinned with water to a washy consistency. If you use the paint too thickly, the wings will look solid.

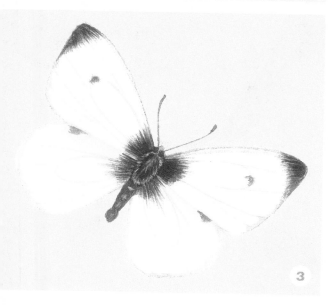

Southern Dogface Butterfly

SHERRY C. NELSON

MEDIUM: *Oil*

COLORS: **Winsor & Newton Artists' Oil Colour:** *Ivory Black • Titanium White • Raw Sienna • Raw Umber • Cadmium Yellow Pale*

BRUSHES: **Sherry C. Nelson Red Sable:** *nos. 2 and 4 brights, no. 0 round*

OTHER SUPPLIES: *Odorless thinner*

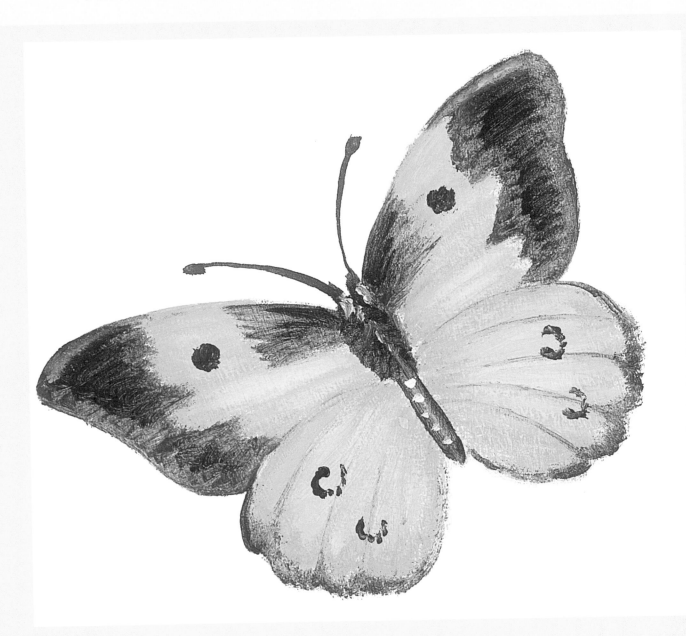

1

1 Paint Yellow Marks

Base the yellow areas of the butterfly with a bursh-mix of Cadmium Yellow Pale + Raw Sienna using the no. 4 bright brush.

2 Highlight and Add Brown Marks

Place a dirty brush + Titanium White highlight in the central areas of each section of yellow. Basecoat the brown areas with a brush-mix of Raw Sienna + Raw Umber using the no. 2 bright brush.

3 Blend and Shade

Blend highlights in the yellow sections that show growth direction. Add patches of shading within the brown wing tips with Ivory Black + a bit of Raw Umber. Basecoat the body with Raw Umber + Ivory Black.

4 Add Final Details

(See the finished painting on page 32.) Using the chisel edge, tap in the veining in the yellow areas of the wings with a sparse brush-mix of Raw Sienna + Raw Umber. Add an irregular outline around the hind wings with the same mix, using the tip of the no. 0 round brush. Add detail spots with the round brush using Raw Umber + a bit of Ivory Black. Soften the black shading in the brown wing tips a little. Thin a little of the Raw Umber + Ivory Black brush-mix with odorless thinner and use the round brush to make the antennae lines. Detail the body with a bit of dirty white, again using the round brush.

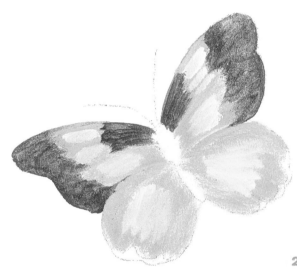

2

artist's comment

In this demonstration, the "+" sign indicates brush-mixed colors. These mixes vary naturally and create a more realistic look than palette-knife mixes do. Continue using the same brush type and size in each area unless instructed to switch to a different size.

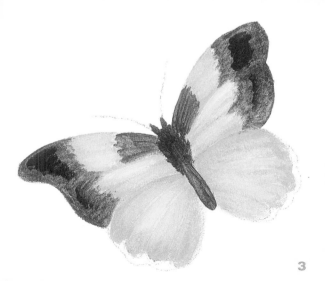

3

Morpho Butterfly

CINDY AGAN

MEDIUM: *Watercolor*

COLORS: **Winsor & Newton Artists' Water Colour:** *Cobalt Turquoise Light* • *Indanthrene Blue* • *Mars Black* • *Burnt Umber* • **Van Gogh:** *Phthalo Blue* • **Holbein:** *Manganese Blue Nova*

BRUSHES: **Jack Richeson 9000 Series:** *nos. 2 and 4 rounds*

OTHER SUPPLIES: *140-lb. (300gsm) cold-pressed Arches watercolor paper size 8½" × 10½" (21cm × 27cm) • no. 3H pencil*

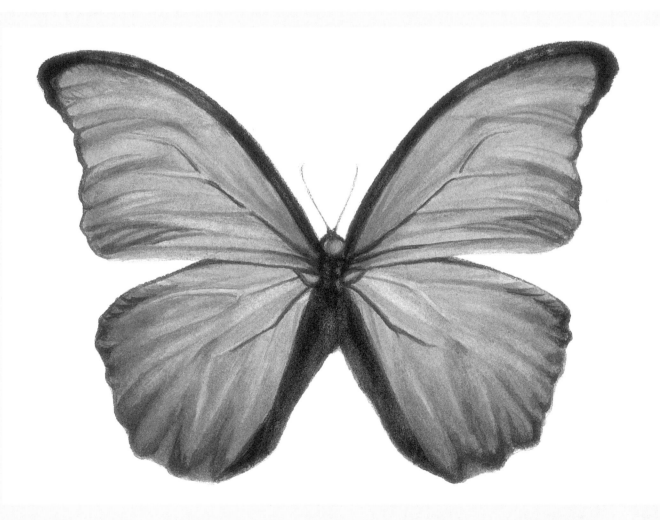

1 Outline the Details
Draw a detailed sketch of the butterfly with a 3H pencil. Begin with a no. 2 round and drybrush the veins, folds and creases in the wings with Phthalo Blue. Follow the drawing closely, and gently soften this outline with a damp brush.

2 Add Value
Erase any visible pencil lines. Deepen the color value in the veins with Phthalo Blue and make the veins more pronounced with a no. 2 round. Let dry completely. Working around the highlights, indicate the shadows in the wings with a thin wash of Phthalo Blue using a no. 4 round.

artist's comment

Phthalo Blue, used in this demo, is a staining color and will permanently stain the white of the paper. It cannot be lifted completely for corrections or highlights. With that in mind, plan carefully and create a detailed drawing before applying the paint to save yourself much time and trouble.

Morpho Butterfly

3

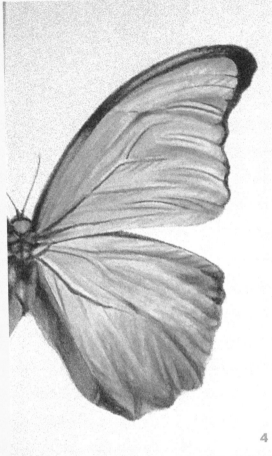

4

3 Add Color

To create the illusion of iridescent shades of blue and green, drybrush a touch of Cobalt Turquoise Light in the highlighted areas with a no. 4 round and let dry. Add a wash of Manganese Blue Nova gently over the wings. When dry, apply Phthalo Blue on the outer edges of the wings and on the wings next to the butterfly's head.

4 Add Depth

To give the wings more shape and depth, thin Mars Black to a dark gray and use a no. 4 round to apply it to the outer edges of the wings and near the head. When dry, alternate between Phthalo Blue and Cobalt Turquoise Light to further define the folds and creases. Let dry. Lightly glaze Phthalo Blue over these areas to soften and blend. Drybrush a darker concentrate of Mars Black on the body and outer portions of the wings. Be sure to "mirror" each step on the right and left sides of the delicate wings.

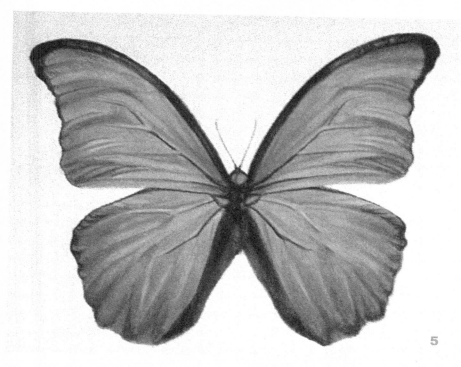

5

5 Apply Final Glazes

With a no. 4 round, lay in a mixture of Phthalo Blue and Mars Black (1:1) on the outer edges of the wings and pull toward the center of the butterfly's body with a clean, damp brush. Apply this mixture next to the head, and pull away from the body toward the outside edge of the wings with a damp brush. Painting around the subtle highlights, apply multiple glazes over the entire area of the wings, letting the area dry between each glaze.

Next, apply Burnt Umber to the body and the black portions of the wings in the center. Repeat glazes of Phthalo Blue and the mixture of Mars Black and Phthalo Blue until you are satisfied with the color intensity. To finish, drybrush Mars Black with a no. 2 round on the body and the edges of the wings and apply thin shadow lines to the veins.

Peacock Butterfly

BARBARA LANZA

MEDIUM: *Watercolor*

COLORS: **Winsor & Newton Pigments:** *Burnt Umber • New Gamboge • Yellow Ochre • Chinese Orange • Ivory Black • Purple Madder • Sepia • Chinese White*

BRUSHES: **Winsor & Newton Series 7 Kolinsky Sable:** *nos. 000, 0, 1 and 3 rounds*

OTHER SUPPLIES: *Hot-pressed Fabriano Artistico Bright White watercolor paper • graphite transfer paper no. 2H pencil • kneaded eraser*

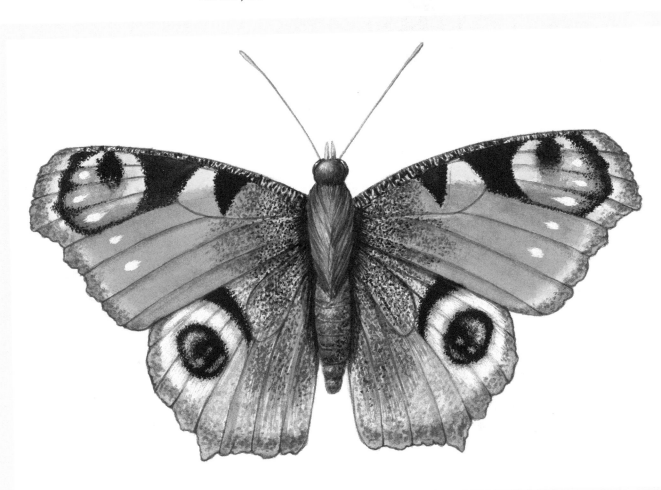

1

2

3

4

1 Transfer sketch

Transfer the pencil drawing onto watercolor paper using graphite transfer paper and a no. 2H pencil. Remove any excess graphite by pressing a kneaded eraser over the area.

2 Apply Light Tint

Using a no. 3 round, apply a light tint of New Gamboge to the entire butterfly. Let dry.

3 Apply Medium Tint

Mix equal amounts of Yellow Ochre and Burnt Umber to make a medium tint. Using a no. 1 round, apply this tint to the outer edge of the wings and wing spots beginning at the pencil line. Rinse the brush and dip it in clean water to blend the edges of the color outward.

Apply the medium tint to the upper body and around the body segments using the same brush. Begin adding details to the upper edge of the wings and to the wings on each side of the body with a dark tint of Sepia loaded on a no. 000 round. Holding the brush perpendicular to the paper, apply dots of Sepia between the wing veins. Let dry.

4 Detail Wing Markings

Add a medium tint of New Gamboge to the top wing markings using a no. 1 round. Apply a medium tint of Burnt Umber on the outer edge of the wings. Blend inward using a rinsed no. 1 round.

artist's comment

When looking through books on butterflies, I try to guess how they got their names. Obviously, this butterfly was named not for the color of its namesake, but for its large oval markings. If I were a butterfly predator, those "eyes" would be warning enough to stay away.

Peacock Butterfly

5

6

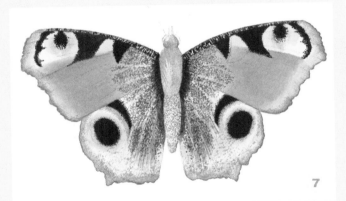

7

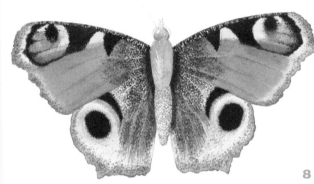

8

5 Apply Orange Tint

Using a no. 3 round, paint medium-tint bands of Chinese Orange on the top wings. With a no. 000 round, apply a medium tint of Chinese Orange in fine strokes for the hairs on the bottom wings.

6 Apply Yellow Tint

Using a no. 1 round, carefully apply a light tint of New Gamboge over the dots on the wings on both sides of the butterfly's body. Load a medium-tint mixture of Yellow Ochre and Burnt Umber on a no. 000 round and apply dots to the outside painted area of the lower markings and the arch of color above them.

7 Paint Dark Markings

Using a no. 1 round loaded with a dark tint of Ivory Black, paint the markings on the top and bottom wings. Let dry. Using a no. 000 round loaded with the same tint, paint dot outside the markings, gradually lessening the amount as yo paint outward.

8 Add More Details

Mix equal amounts of Yellow Ochre and Burnt Umber to create a medium tint. With a no. 000 round, paint dots between the black dots on both sides of the body. Using a no. 1 round, apply Purple Madder to the detail on top of t wings. Let dry. Using a no. 000 round, apply dots of Ivory Black on top.

9

9 Paint Wing Veins and Body

Using a no. 000 round loaded with a medium tint of Sepia, paint the veins on the wings and the rounded form of the body. Let dry. With a no. 000 round, apply a darker tint of Sepia in fine strokes for the hair on the body. Using the same brush, apply Ivory Black dots to the body. Let dry.

10 Add Details

Paint dots of New Gamboge between the black dots. With a no. 000 round, paint fine strokes of Chinese Orange in a diagonal pattern for the hair on the butterfly's body. Add Ivory Black dots to the body using a no. 000 round. Fill the spaces in between with dots of a mixture of Chinese Orange and New Gamboge. Using a darker tint of New Gamboge loaded on a no. 1 round, paint over the yellow markings on top of the wings. Outline the wings using a no. 000 round loaded with a dark tint of Sepia. Paint the antennae using a mixture of New Gamboge and Burnt Umber.

11 Finish with White Markings

With a no. 0 round brush loaded with Chinese White, apply short strokes on the markings on the top and bottom wings.

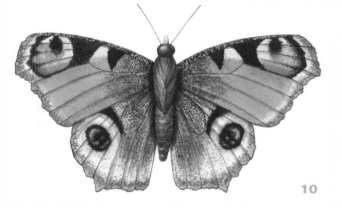

10

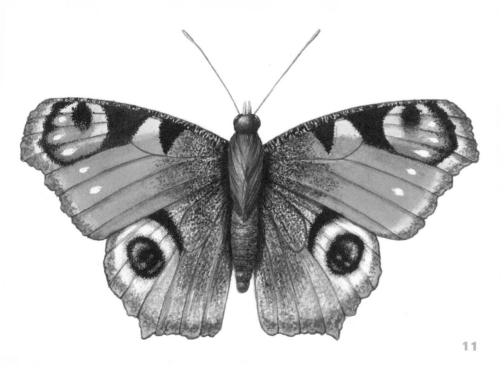

11

Painted Lady

CINDY AGAN

MEDIUM: *Watercolor*

COLORS: **Winsor & Newton Artists' Water Colour:** *Transparent Yellow • Cerulean Blue (Red Shade) • Sep.* *• Mars Black •* **Da Vinci:** *Cadmium Orange*

BRUSHES: **Jack Richeson 9000 Series:** *no. 4 round •* **Silver Brush Ultra Mini:** *no. 10/0 script*

OTHER SUPPLIES: *140-lb. (300gsm) cold-pressed Arches watercolor paper, 8½" × 10½" (21cm × 27cm)* *no. 3H pencil • masking fluid • brush soap*

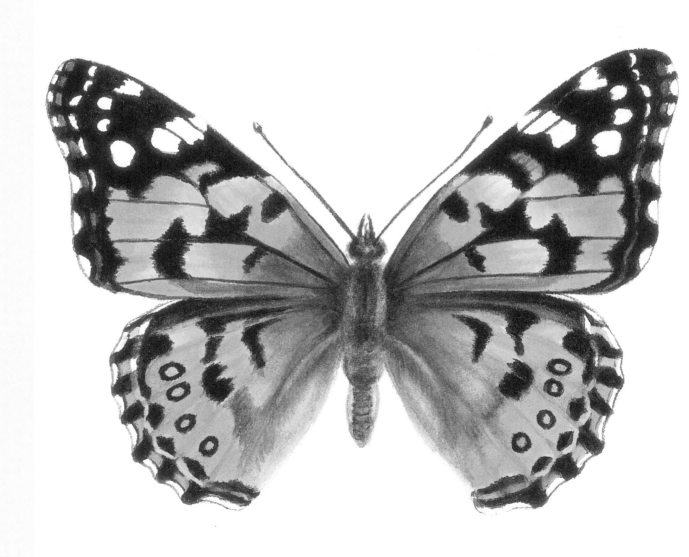

1 Mask Out the Markings

Draw a detailed sketch with a no. 3H pencil. Moisten the bristles of a no. 10/0 script brush and dip in liquid soap or brush soap. Apply masking fluid to the white and blue markings on the butterfly wings, as well as the markings on the inner edge of the wings. Rinse your brush frequently and "re-soap" to prevent a sticky buildup.

2 Paint the Body

With a no. 4 round, paint a light glaze of Transparent Yellow on the body of the butterfly and let dry completely.

Mix a warm green with Cerulean Blue (Red Shade) and Transparent Yellow (2:1) and add a touch of it to the body.

Thin Sepia and use it to define the head of the butterfly, and to underpaint the wing area around the body. When dry, apply a glaze of Cadmium Orange to the markings on the wings.

artist's comment

There are several different brands of paint to choose from, and you will find that many will share the same name of a particular pigment, such as Cadmium Orange, but they are not all alike! Da Vinci's Cadmium Orange is a bright red-orange—which is needed in this demonstration of the painted lady butterfly—whereas Winsor & Newton's Cadmium Orange is a yellow-orange and would never achieve the effect you are looking for. That is why an artist often suggests a certain brand and color for a painting—they want to save you a lot of frustration!

Painted Lady

3

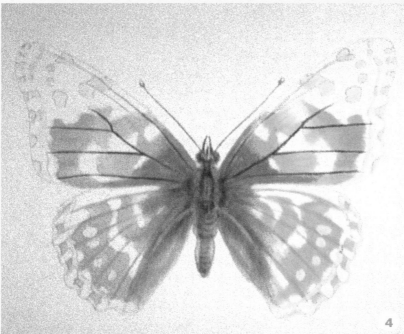

4

3 Enrich the Color
Continue to glaze Cadmium Orange over the body and wings, including the Sepia underpainting on the wings around the body. Let dry and repeat. Lift a few highlights on the wings with a damp brush to give the wings shape.

4 Add Veins and Details
Drybrush the veins in the top wings with Mars Black and use a strong concentrate of Cadmium Orange for the veins in the bottom wings. Mix Cadmium Orange and Mars Black (2:1) to create a warm brown and use it to apply a few details to the head, body and surrounding area. For depth, add a few shadows and details to these same areas with Mars Black and let dry. Glaze a thin layer of Transparent Yellow over the brown, green and orange markings for warmth. When dry, drybrush Cadmium Orange again to brighten the color in the wings.

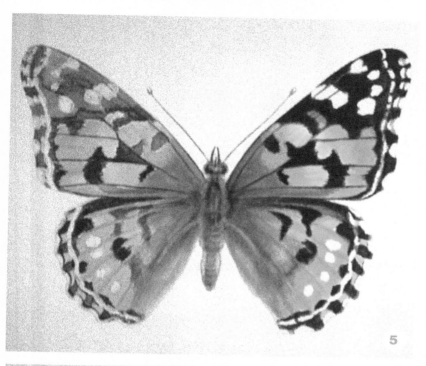

5

5 Define and Blend

Paint the pattern in the wings using Mars Black. Carefully blend and soften the edges into the orange areas with a damp brush. It's safe to paint over the masking fluid. (The wing on the left side shows this step in the beginning stages.) On the right wing, drybrush the black markings, let dry, then remove the masking fluid. Intensify and touch up areas with Transparent Yellow and Cadmium Orange where needed. Repeat this process on the left wing.

6 Add the Fine Details

After removing the masking fluid, smooth any rough edges with Mars Black. Drybrush a brown mixture of Cadmium Orange and Mars Black on the markings near the edge of the wings. Using Cerulean Blue (Red Shade), drybrush the four blue circles on the bottom of each wing. When dry, surround this blue with Mars Black. Look over your painted lady closely and adjust color as needed.

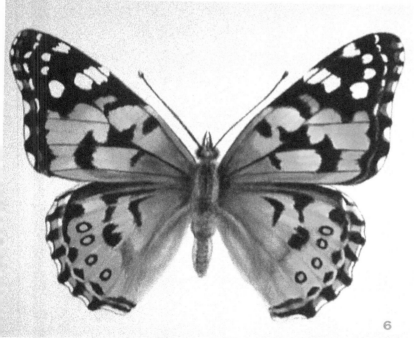

6

Moths

Moths are often viewed as unattractive pests. Some species, however, have markings that are as interesting as those of butterflies, and are worth a second look.

Geometrid

SHERRY C. NELSON

MEDIUM: *Oil*

COLORS: **Winsor & Newton Artists' Oil Colour:** *Ivory Black • Titanium White • Raw Sienna • Raw Umber • Sap Green*

BRUSHES: **Sherry C. Nelson Red Sable:** *no. 2 bright; no. 0 round*

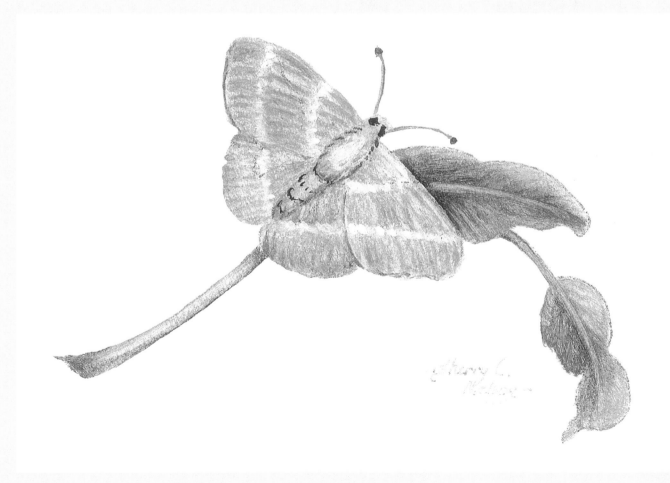

1 Base Moth and Leaves

Base the wing sections with a brush-mix of Sap Green + Raw Sienna + Titanium White using the no. 2 bright brush. Base the body with Raw Sienna. Base darks on the leaves and stem with Ivory Black + Sap Green.

2 Add Texture and Highlights

Use the dry, dirty, chisel edge of the brush to set in the texture lines on the wings. Highlight the trailing edge of the forewings with Titanium White. Highlight the central area of the body with Titanium White. Fill in the remaining leaf and stem areas with Sap Green + Raw Sienna + Titanium White.

3 Blend Highlights

Shade under the edges of the forewings and in a few places at the margins of the wings with Raw Sienna + Raw Umber.

Thin a little Raw Sienna and draw antennae with the no. 0 round brush.

Blend highlights on the body and shade with a bit of Raw Umber around the edges. Blend the leaves following the lateral growth direction, and highlight in a few places with the dirty brush + Titanium White.

4 Add Details

(See finished painting on page 46.) Detail the wings, tapping in the white divisions between wing sections with the no. 0 round brush using pure Titanium White, making them irregular and softened into the greens just a bit.

Add detailing on the body with slightly thinned Raw Umber + a bit of Ivory Black. Blend highlights on leaves. Accent the leaves with Raw Sienna. Add central vein lines with the light-green brush-mix from Step 2, using the chisel edge.

artist's comment

In this demonstration, the "+" sign indicates brush-mixed colors. These mixes vary naturally and create a more realistic look than palette-knife mixes do. Continue using the same brush type and size in each area unless instructed to switch to a different size.

Noctuid

SHERRY C. NELSON

MEDIUM: *Oil*

COLORS: **Winsor & Newton Artists' Oil Colour:** *Ivory Black • Titanium White • Raw Sienna • Raw Umber • Sap Green*

BRUSHES: **Sherry C. Nelson Red Sable:** *nos. 2 and 4 brights; no. 0 round*

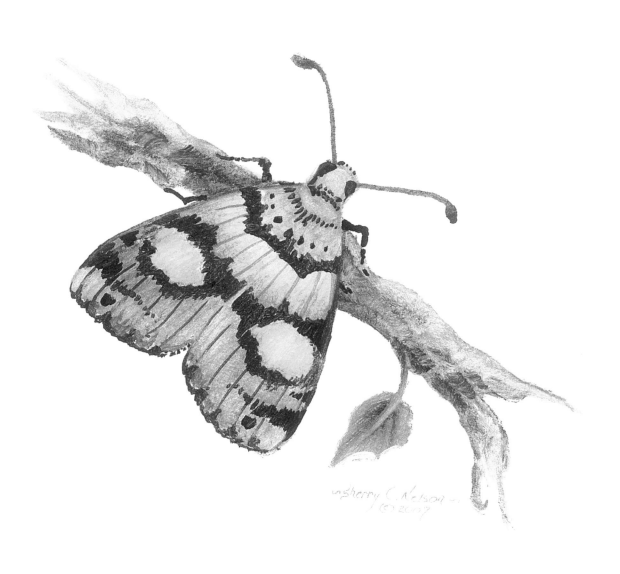

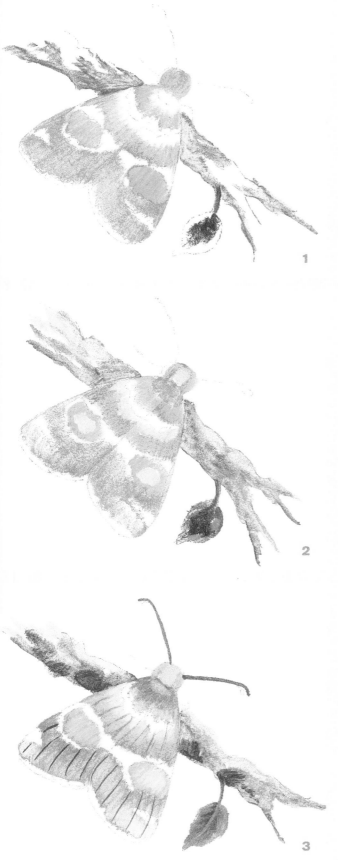

1 Base Wings and Twig

Base the tan wing spots, bands and head with Raw Sienna + a bit of Titanium White using the no. 2 bright. Base the gray areas of the wing with Raw Umber + Titanium White.

Use a bit of slightly thinned Raw Umber to texture the shadow areas of the branch. Use Sap Green + Ivory Black to base the dark areas of the leaflet and stem.

2 Add Highlights and Finish Base

Highlight the tan wing spots and head with Titanium White. Highlight the gray wing areas with a dirty brush + Titanium White. Base the upper half of the tan band with a dirty brush + Titanium White.

Base the rest of the branch with a dirty brush + Titanium White. Base the light value on the leaflet with Sap Green + Raw Sienna + Titanium White.

3 Blend and Shade

Blend highlights in all areas to soften them. Blend the values on the tan band where they meet.

Add faint veining on the tan band with slightly thinned Raw Sienna using the no. 0 round. Add faint veining on the gray band with slightly thinned Raw Umber + Raw Sienna. Use thinned Raw Umber to draw antennae.

Shade the branch with Raw Umber. Blend the leaflet following the lateral growth direction and create the center vein with the light-value green brush-mix from Step 2.

4 Add Dark Bands and Patterns

(See finished painting on page 48.) Add the final detailing using slightly thinned Raw Umber + Ivory Black and the no. 0 round. Pull the dark division sections with successive tiny lines, creating an irregular edge on the dark bands. Add a wing margin pattern, small dots and detail on the head and legs with the same brush-mix.

Tip the antennae with Raw Umber, then highlight with dirty white. Soften the shading on the branch, but leave it choppy in texture. Add a bit of highlight on the leaf with a very light green mix.

artist's comment

In this demonstration, the "+" sign indicates brush-mixed colors. These mixes vary naturally and create a more realistic look than palette-knife mixes do. Continue using the same brush type and size in each area unless instructed to switch to a different size.

Sphinx Moth

BARBARA LANZA

MEDIUM: *Watercolor*

COLORS: **Winsor & Newton Artists' Water Colour:** *Permanent Mauve • Payne's Gray • Ivory Black • Yellow Ochre • Cobalt Blue • Burnt Umber • New Gamboge • Chinese White •* **Holbein:** *Opera*

BRUSHES: **Winsor & Newton Series 7 Kolinsky Sable:** *nos. 000, 0, 1, 2 and 3 rounds*

OTHER SUPPLIES: *Hot-pressed Fabriano Artistico Bright White watercolor paper • graphite transfer paper no. 2H pencil • kneaded eraser*

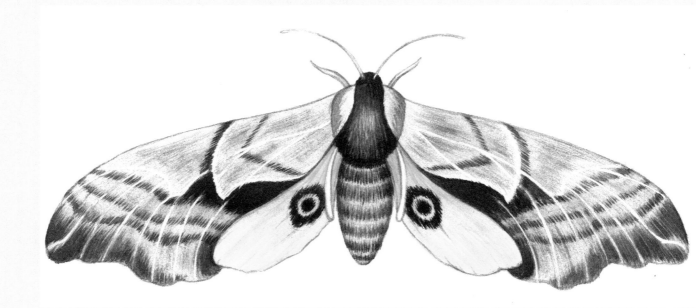

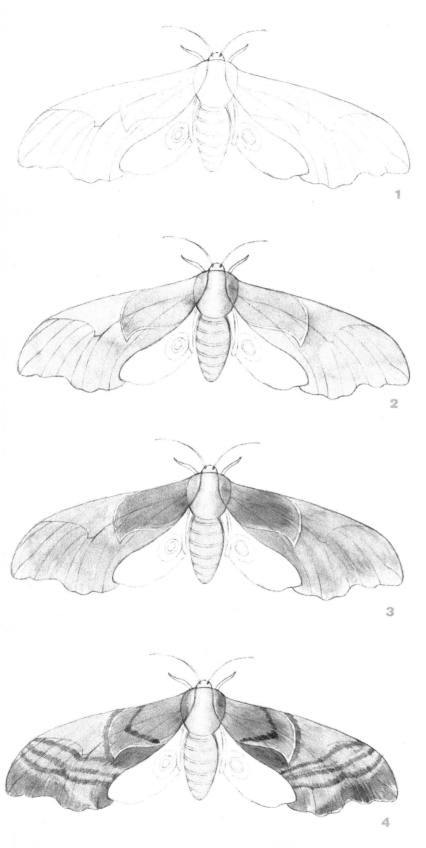

1 Transfer Drawing

Transfer your pencil drawing onto watercolor paper using graphite transfer paper and a no. 2H pencil. Remove any excess graphite by pressing a kneaded eraser over the area.

2 Tint Upper Wings

Using a no. 3 round, apply a pale tint of Permanent Mauve to the entire upper wing area and body of the moth.

3 Darken Upper Wings

Mix equal amounts of Payne's Gray and Ivory Black. Using a no. 1 round, apply this mixture to the upper wings leaving the V-shaped pattern unpainted.

4 Detail Upper Wing

Wet the entire upper wing area with a no. 2 round. When the shine is gone, use a no. 000 round to apply long, fine strokes of Payne's Gray to the wings.

When dry, apply a darker tint of Payne's Gray to the wing pattern detail in short, fine strokes.

artist's comment

I find moths more fascinating than butterflies. When their wings are closed, moths take on the look of curled leaves and tree bark, making them harder to spot and thus more mysterious. When approached, moths unfurl their wings and surprise us with unexpected colors and markings.

Sphinx Moth

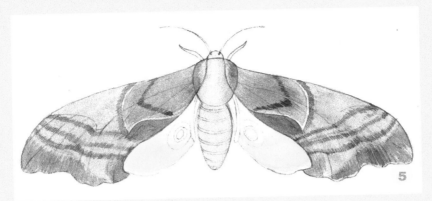

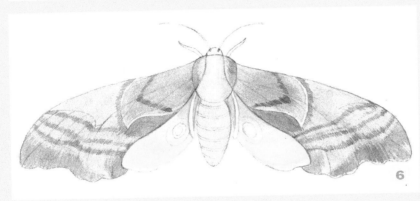

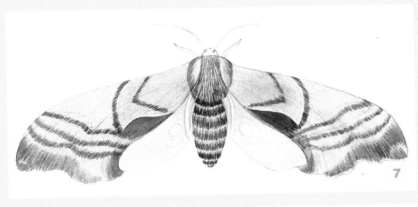

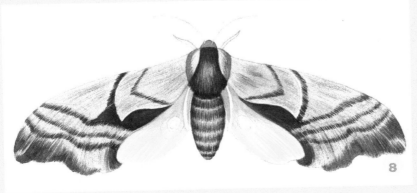

5 Tint Lower Wings

Wet the lower wing using a no. 1 round. When the shine is gone, apply Yellow Ochre to the lower part of the lower wing. Let dry.

6 Tint Lower Wings

Re-wet the lower wing as before. When the shine is gone, apply Opera to the upper part of the lower wing, blending it over the Yellow Ochre with clean water.

7 Add Texture and Patterns

Mix a small amount of Ivory Black and Payne's Gray. Dip an old, scruffy brush in this mixture and let the paint begin to dry on the brush. Drag the color lightly over the wing to create texture. Let dry.

With a medium tint of Ivory Black loaded on a no. 000 round, apply short strokes to form wing and body patterns. Fill the solid area at the inner center of the wing with the same color.

8 Detail Lower and Upper Wings

Using a no. 0 round, apply a darker tint of Yellow Ochre over the first coat on the lower wings. Let dry. Using a no. 000 round, apply darker strokes of Yellow Ochre for detail. Let dry.

Using a no. 0 round, apply a darker tint of Opera over the first coat. Let dry. Using the same brush, apply darker strokes of Opera for detail.

Using a no. 000 round, apply Ivory Black in tiny strokes over the wing patterns. Fill solid areas with a dark tint of Ivory Black.

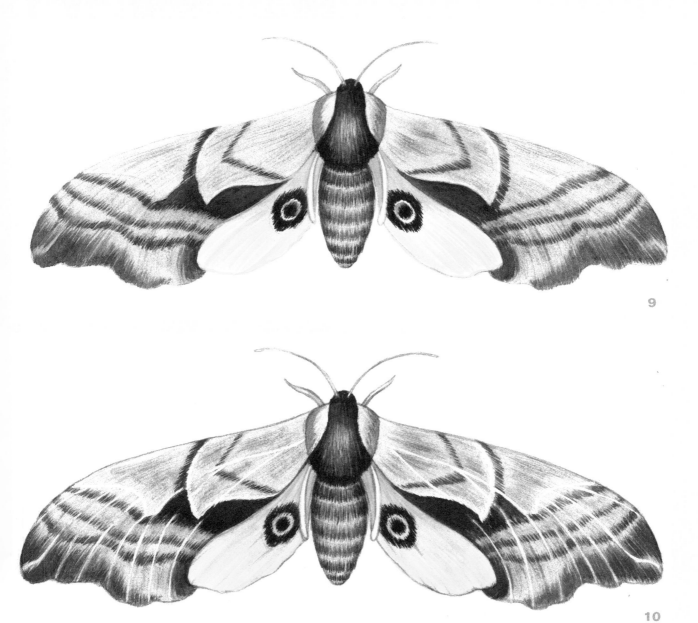

9

10

9 Paint Eye Spots

Wet the center circle of the lower wing detail. Using a no. 000 round, apply a medium tint of Cobalt Blue. Let dry.

Rinse the brush and apply short strokes of Ivory Black over most of the Cobalt Blue. Paint the outer ring in short strokes. Keep all of your strokes in the same direction—on the diagonal. Apply a medium tint of Burnt Umber over the solid blacks on the top wings. Apply Ivory Black using a no. 000 round and add darker strokes to the moth's body.

10 Add Final Tints and Details

Using a no. 1 round, apply New Gamboge over the Yellow Ochre. Add a darker tint of Opera using a no. 0 round. Dry-brush a darker tint of Ivory Black to add more texture to the upper wings. Outline the lower wings using a no. 000 round and a medium tint of Burnt Umber. Outline the upper wings using a no. 000 round and a medium tint of Payne's Gray. Using a no. 000 round, apply Chinese White to the upper wing veins in short, fine strokes.

Songbirds

The happy chirps and bright colors of songbirds bring joy to any scene. They are a welcome sight both in gardens and paintings.

Goldfinch 1

DAVID LEE

MEDIUM: *Watercolor*

COLORS: **Winsor & Newton Artists' Water Colour:** *Cadmium Lemon • French Ultramarine • Prussian Blu* • *Sap Green • Vandyke Brown • Yellow Ochre • Potter's Pink • Alizarin Crimson • Burnt Sienna*

BRUSHES: **Winsor & Newton:** *no. 0 sable short liner •* **Grumbacher:** *nos. 2, 6, 8 and 12 sable round • no.* *script liner*

OTHER SUPPLIES: *140-lb. (300gsm) cold-pressed Arches watercolor paper • masking fluid • Faber-Castell nos. 2B and HB pencils • Staedtler Mars Plastic eraser*

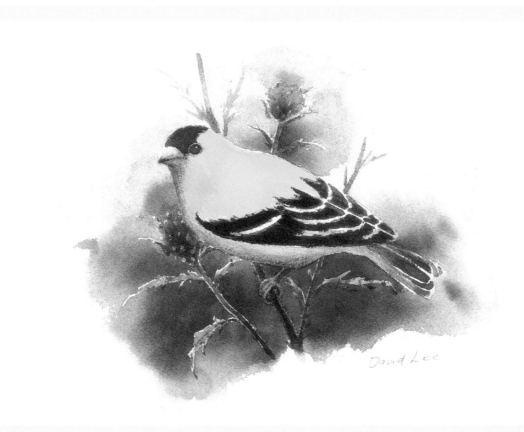

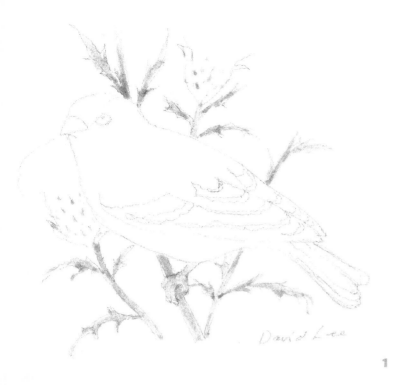

1

1 Create Sketch and Apply Masking Fluid

Use no. 2B and HB pencils to make a detailed sketch of the goldfinch with a simple background of thistles based on collected reference materials.

Using a thin stick, apply masking fluid to preserve small areas that might be difficult to paint around.

2 Paint Light Sections

When the masking fluid dries, use a no. 6 or 8 round to apply Cadmium Lemon Yellow and a touch of Yellow Ochre to the goldfinch body. Glaze a second, thin layer of this mixture to enrich the color.

Apply a darker mixture (Yellow Ochre + Vandyke Brown + Prussian Blue) at the lower portion of the body to create shading.

Use light gray for the lower body near the tail area. Apply Potter's Pink to the beak and Vandyke Brown at the edge of the beak.

artist's comment

The goldfinch is the state bird of New Jersey. Its bright yellow plumage makes it strikingly beautiful. A couple of technical tips for reference:

- To enrich a color by glazing, be sure the surface is completely dry between each application of thin layers. A hair dryer works well.
- To preserve and protect your watercolor paper, sketch your composition on regular paper first. Once you're happy with the design, transfer it to watercolor paper using tracing paper.
- Use a dry brushstroke to give the feather area softer edges.

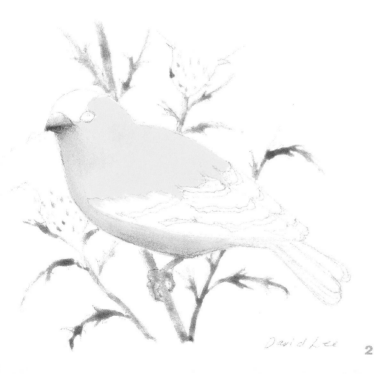

2

Goldfinch 1

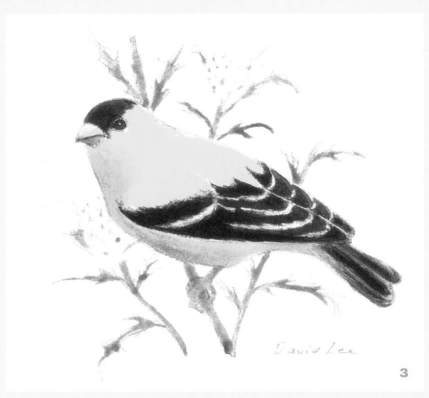

3 Paint Black Markings

Create a black by mixing approximately 60 percent French Ultramarine + 40 percent Vandyke Brown. Paint the black areas using a no. 0 sable short liner for fine lines and nos. 2 and 6 sable rounds for the black patterns on the wings, head, eye and tail.

4 Paint Background

Using the no. 6 round and no. 5 script liner, paint the thistle blooms with Alizarin Crimson and the leaves and stems with a mixture of Sap Green and Burnt Sienna.

Using nos. 8 and 12 rounds, loosely paint the background with more complimentary colors of Sap Green and Prussian Blue and a touch of Burnt Sienna.

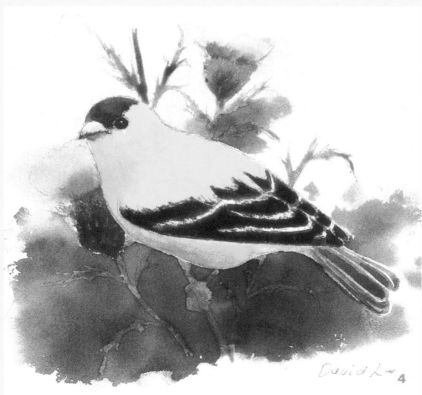

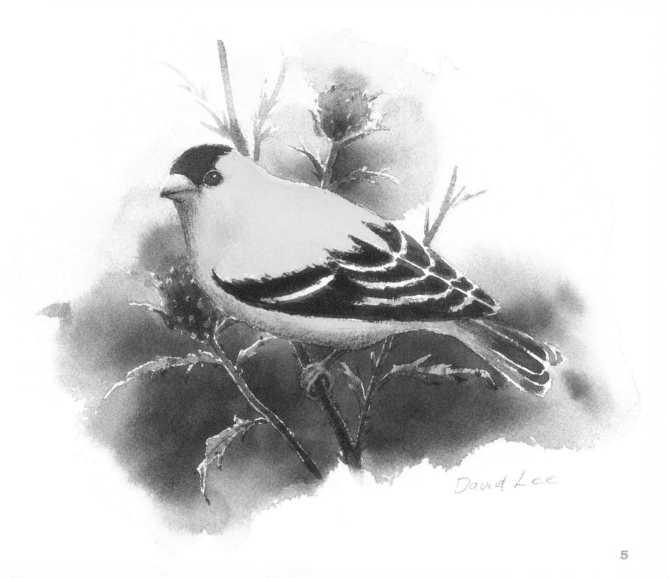

5

5 Add Final Details

Remove the masking fluid from the preserved areas. Touch up and smooth out the rough edges. Use green (Sap Green + Burnt Sienna) and dark green (green mixture + Vandyke Brown) with a no. 6 sable round and a no. 5 script liner to paint the leaves and stems. Paint the claw with Vandyke Brown. Remove pencil lines if you prefer and make any final adjustments.

Goldfinch 2

CINDY AGAN

MEDIUM: *Acrylics*

COLORS: ***Liquitex Soft Body:*** *Titanium White • Cadmium Yellow Light • Cadmium Yellow Medium • Raw Umber • Cadmium Red Deep Hue • Mars Black*

BRUSHES: ***Robert Simmons Expression Series E85:*** *nos. 3 and 3/0 rounds*

OTHER SUPPLIES: *140-lb. (300gsm) cold-pressed watercolor paper, 8½" × 10" (21cm × 25cm) • no. 3H pencil*

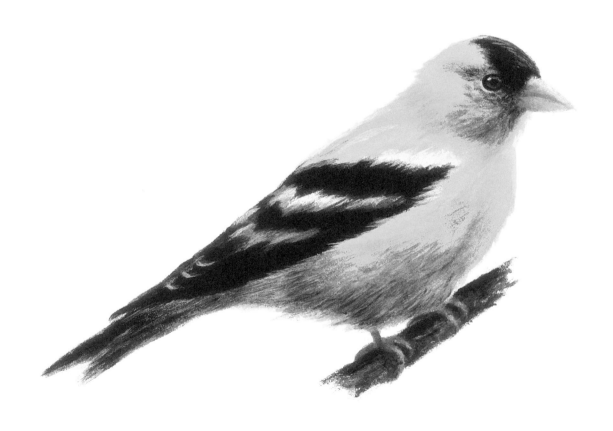

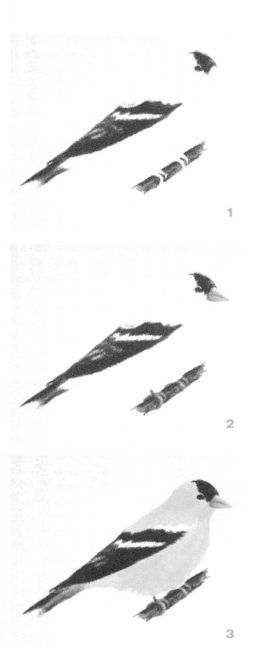

1

2

3

1 Begin With Darkest Value

Draw a detailed sketch of the goldfinch with a 3H pencil. Determine which direction the light is coming from and indicate where the shadows will fall. Using a no. 3 round, apply Mars Black to the black markings on the forehead, wing, tail and eye, painting around the white stripe on the wing.

2 Paint the Beak and Feet

Mix Cadmium Red Deep Hue and Cadmium Yellow Medium (2:1) and use this color as a base for the beak and feet. Add a touch of Titanium White to this mixture for a few highlights. Add a touch of Cadmium Yellow Medium to the beak mixture and warm up the lower half of the beak where the yellow feathers are reflected. Use Raw Umber on the beak and feet for the deepest shadows.

3 Build the Foundation

Thin Mars Black and glaze the tail. When dry, add water to Titanium White and paint a few feathers over the black. Apply Cadmium Yellow Light to the head, back, chest and belly. Add subtle shadows with Cadmium Yellow Medium.

4 Give the Bird Shape and Dimension

(See the finished painting on page 58.) Mix a medium gray from Titanium White and Mars Black (2:1) and use it to tone down the tail, to create a few highlights on the forehead and to define a few markings on the tail. For the eye, mix just a touch of Titanium White with Raw Umber and paint the iris. Use Mars Black for the pupil and around the eye, and Titanium White for the highlight in the eye.

To give the body shape and the feathers a natural look, begin with the darkest colors and gradually build up the color, making each layer lighter than the previous. Switch to a no. 3/0 round for optimum detail. Paint the tiny feathers in the order listed, varying the placement for interest: Raw Umber and Mars Black (3:1); Raw Umber; Cadmium Yellow Medium; Cadmium Yellow Light, Cadmium Yellow Medium and Titanium White (1:1:2); Cadmium Red Deep Hue and Cadmium Yellow Light (1:1). Then add a touch more Cadmium Yellow Light to the Cadmium Red Deep Hue and Cadmium Yellow Light mixture. Finish the top layer of feathers by adding Titanium White to this mixture.

artist's comment

Create fine lines to paint the feathers by using the tip of a round brush of any size. Load the brush with color and gently drag it across a paper towel to flatten the brush hairs for a razor-sharp edge. Now turn the brush to a comfortable angle and paint short, irregular strokes, blending one color into the next for convincing plumage.

Hummingbird 1

LIAN ZHEN

MEDIUM: *Chinese watercolor*

COLORS: **Chinese painting colors or sumi colors:** *yellow • Phthalo Blue • Carmine • white*

BRUSHES: **Chinese brushes:** *small and medium*

OTHER SUPPLIES: *Raw Shuan paper (unsized rice paper), 8" × 10" (20cm × 25cm) • Chinese painting in or sumi ink*

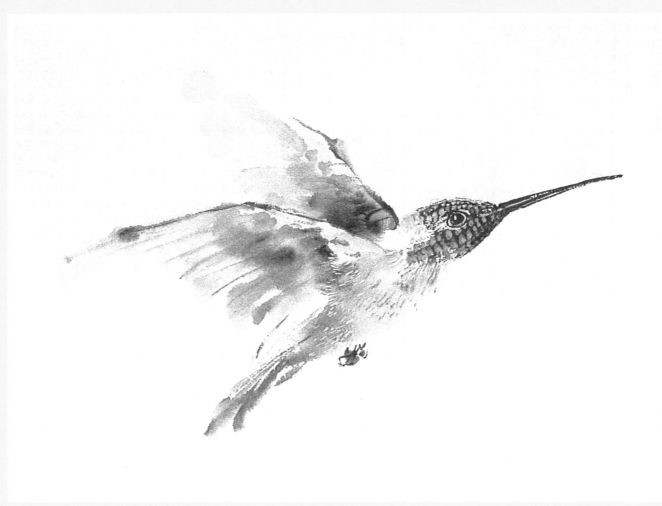

1 Paint Head

Use a small brush to paint the head, eye and beak with intense ink. Make sure the brush contains very little water.

2 Paint Wings and Body

Load white on the heel of a medium brush and load yellow and Phthalo Blue on the middle and tip. Hold the brush sideways to paint the wings, body and tail with few strokes.

artist's comment

Here are some helpful tips for Chinese watercolor painting:

1. After loading three or four pigments on one brush, dab the brush on the palette a few times to let the pigments blend into each other lightly.
2. Use strokes economically.
3. Control the amount of water on the brush.
4. Try not to change or correct strokes. It is better to throw away the paper and start over.

Hummingbird 1

3 Paint Feathers on Wings and Head

Without washing the medium brush, load ink on its tip to paint the wing feathers with overlapping strokes. Use a different medium brush to mix Carmine and thick white to define the bright pink feathers on the head.

4 Paint Tail Feathers

Continue using the medium brush to paint and ink the tail feathers. Outline the wings with intense ink when the colors on the wings are about half dry.

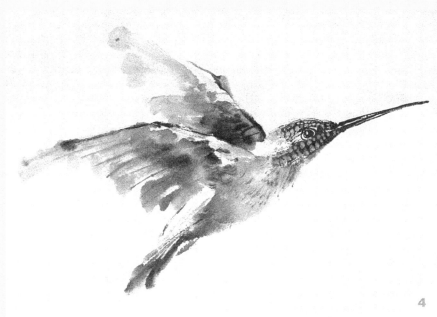

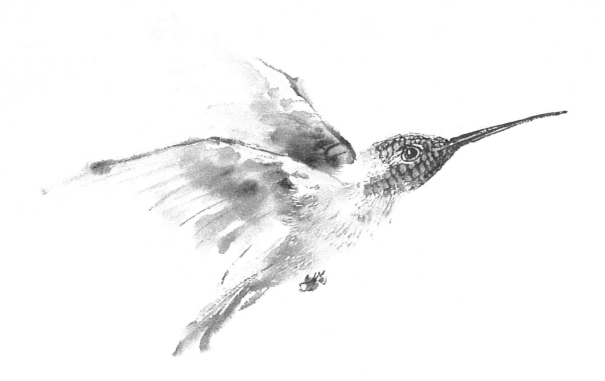

5

5 Paint Chest Feathers and Feet

Use a small brush to define the feathers on the chest first with ink and then with white. Finally, paint the little feet with ink when the colors on the chest are half dry.

Hummingbird 2

VICTORIA LISI

MEDIUM: *Acrylics*

COLORS: **Daler-Rowney System 3 Acrylics:** *Lemon Yellow • Emerald • Crimson • Ultramarine • Mars Black*

BRUSHES: **Robert Simmons Sienna or Expressions Pointed Rounds:** *nos. 0, 2, 4 and 6*

OTHER SUPPLIES: *Hot- or cold-pressed watercolor paper • masking fluid • crow quill pen • stylus • no. H graphite pencil • dish soap • hair dryer • soft eraser or masking fluid remover • Rowney Stay Wet Palette*

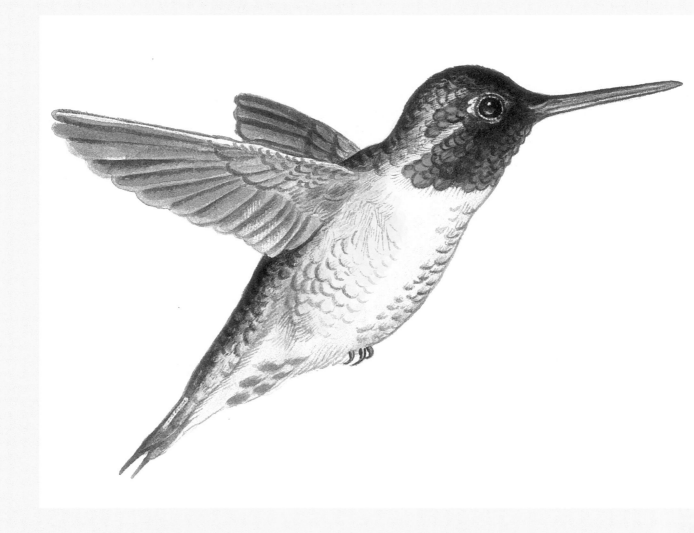

1 Create Drawing

With a no. H graphite pencil, carefully draw the hummingbird on the water-color paper. Mix dish soap with water (1:1). Mix masking fluid with water (1:1).

2 Apply Masking Fluid and Yellow Glaze

Dip the stylus or crow quill pen in the soapy mixture before you dip it into the masking fluid. Preserve the whites with the masking fluid, using the stylus for the larger highlights and the glint in the eye. Use the crow quill pen for the delicate feather details.

Mix Lemon Yellow to a watery glaze. Using no. 4 round, wash the glaze over the hummingbird's back and the dark areas on its head.

artist's comment

Mixing dark, neutral tones from two opposite colors such as red and green produces a more harmonious, unified and brilliant painting than using browns or grays directly from the tube.

Hummingbird 2

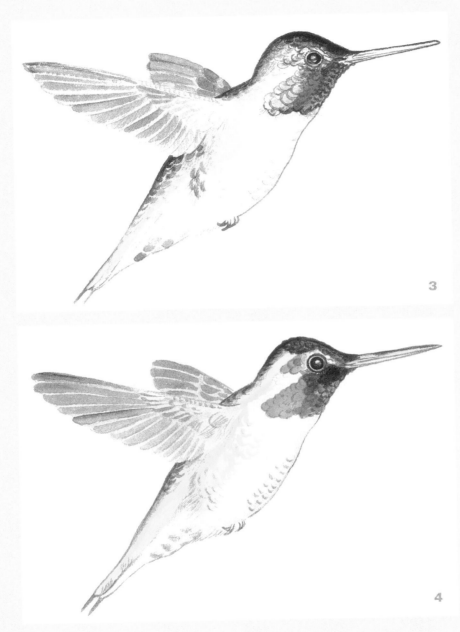

3

4

3 Apply Underpainting

Mix Emerald and Crimson in varying proportions to make two dark values: Emerald + Crimson (2:1) for a greenish dark and Emerald + Crimson (1:2) for a reddish dark. Use varying amounts of water in your paint mixtures from watery to flowing to creamy. This will help vary your values from light to medium to dark. Using the no. 3 round for broad areas and the no. 0 round for small details, paint the back of the bird with the greenish dark. Paint the head, chest and wings with the reddish dark.

Strive to make a complete underpainting with a variety of values. (A good underpainting will make the next steps easier.)

4 Apply Glazes

Mix a watery Lemon Yellow + Emerald (2:1) and glaze over the hummingbird's back with the no. 4 round.

Mix a watery Lemon Yellow + Emerald (1:2) and glaze over the sides and under the wing using the same brush. Clean your brushes, especially between different-colored glazes.

Add a little water to Crimson so it is still thick but flowing and glaze over the red feathers with the no. 3 round. This may require several coats.

Mix a watery Crimson + Lemon Yellow + Emerald (1:1:1) to make brown. Glaze over the wings with a no. 4 round.

Mix a watery Crimson + Ultramarine (1:1) to make purple. Glaze over the beak with a no. 3 round. Wet the hummingbird's chest with a no. 6 round and wash some of this purple into the shadows using the no. 4 round (work wet into wet).

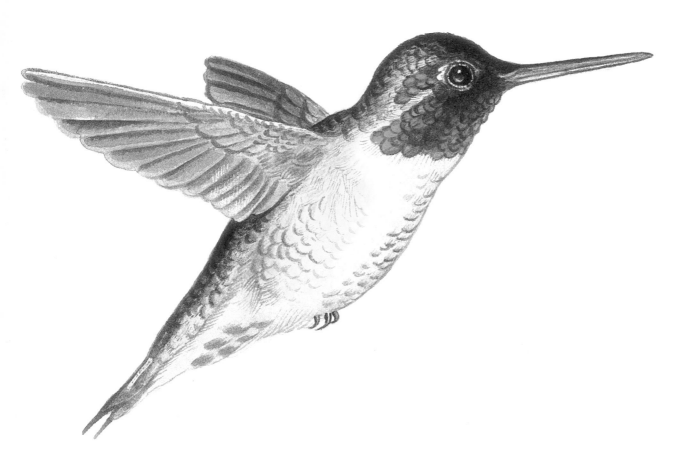

5

5 Add Finishing Touches

Glaze a watery purple (Ultramarine + Crimson [1:1]) over the wings, head and chest with the no. 6 round. While it is still wet, wash some darker (less watery) purple shadows under the belly with the no. 4 round. Use an even darker mixture (little or no water) to restate your darks.

Remove all masking fluid. Mix a variety of darks: Reddish—Crimson + Emerald (2:1); Greenish—Crimson + Emerald (1:2); and Purple—Crimson + Ultramarine (1:1).

Using small round brushes (nos. 0 and 3) and very little or no water, neaten the rough areas around the white highlights with the appropriate color. Add details and darken values as needed. If necessary, add a tiny amount of Mars Black (with little or no water) to the pupil.

Blue-Throated Hummingbird

SHERRY C. NELSON

MEDIUM: *Oil*

COLORS: **Winsor & Newton Artist's Oil Colour:** *Ivory Black • Titanium White • Raw Sienna • Raw Umbe* *• Burnt Sienna • Sap Green • Cadmium Yellow Pale • Winsor Red • Alizarin Crimson • French Ultramarine*

BRUSHES: **Sherry C. Nelson Red Sable:** *Series 303 nos. 2, 4 and 6 brights • Series 312 no. 0 round*

OTHER SUPPLIES: *stylus • odorless thinner*

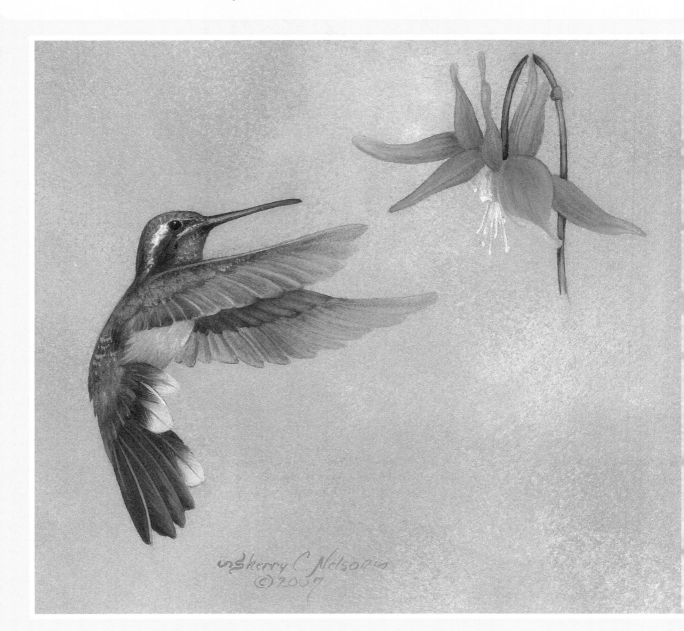

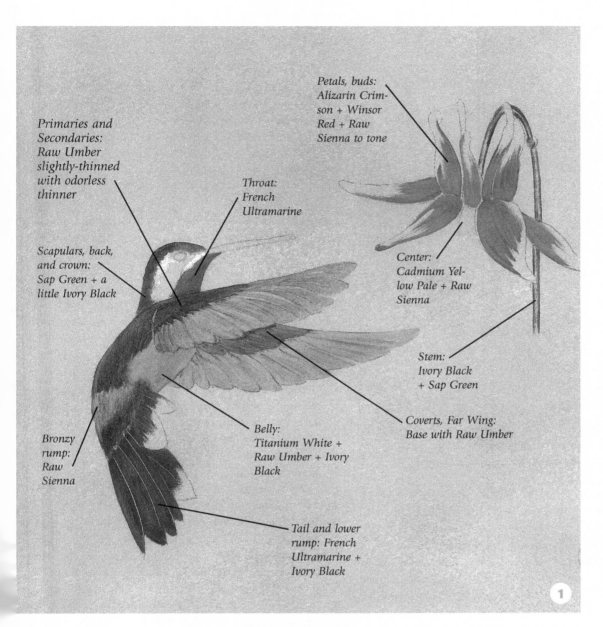

Petals, buds: Alizarin Crimson + Winsor Red + Raw Sienna to tone

Primaries and Secondaries: Raw Umber slightly-thinned with odorless thinner

Throat: French Ultramarine

Scapulars, back, and crown: Sap Green + a little Ivory Black

Center: Cadmium Yellow Pale + Raw Sienna

Stem: Ivory Black + Sap Green

Coverts, Far Wing: Base with Raw Umber

Belly: Titanium White + Raw Umber + Ivory Black

Bronzy rump: Raw Sienna

Tail and lower rump: French Ultramarine + Ivory Black

1 Apply Base

Base the bird and columbine using the colors indicated. Blend the colors a bit where the green or the black meets the bronzy rump.

Paint the fine eye ring with White + Raw Umber. Fill in the Titanium White markings in front of and behind the eye with pure Titanium White.

artist's comment

In this demonstration, the "+" sign indicates brush-mixed colors. These mixes vary naturally and create a more realistic look than palette-knife mixes do. Continue using the same brush type and size in each area unless instructed to switch to a different size.

Blue-Throated Hummingbird

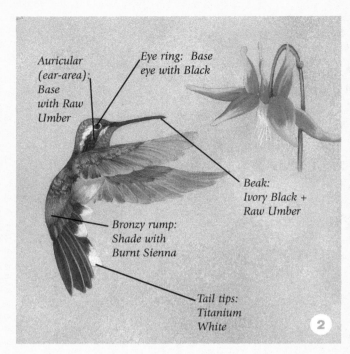

Auricular (ear-area): Base with Raw Umber

Eye ring: Base eye with Black

Beak: Ivory Black + Raw Umber

Bronzy rump: Shade with Burnt Sienna

Tail tips: Titanium White

2

2 Add Details

Use a dirty brush + Titanium White to streak in feather lines along the edges of the long tail feathers. Chop in a little dirty white feathering using no. 2 bright to indicate where edge of coverts overlaps tail.

Use unthinned Raw Umber to shade within far wing feathers and basal feathers on near wing. Lay in the fine lines on the coverts of the far wing with a stylus.

Shade with Ivory Black to separate the wing from the back. The highlight iridescence on the back is created with two brush-mixes. Use Titanium White + French Ultramarine on the bottom half of the back and the wider part of the scapulas. Apply Sap Green + Cadmium Yellow Pale on the top of the back and outside point of scapulas. Apply the colors with the round brush by turns, allowing markings to be more detailed at first. Shade the belly with Titanium White + Ivory Black and highlight with Titanium White.

Highlight the throat with Titanium White + French Ultra-marine, using tiny scalloplike markings with the round brush. Highlight the crown with iridescent markings of Sap Green + Cadmium Yellow Pale.

Add Titanium White and a touch more Raw Sienna to the original petal mixture and use it to paint the lighter sections of the columbine petals. Highlight the center with Titanium White. For stamens, add fine lines of Cadmium Yellow Pale + Raw Sienna and a few with Titanium White, both slightly thinned. Paint the light parts of the stem with Sap Green + Raw Sienna + Titanium White.

3 Add Final Details

(See the finished painting on page 68.) Blend the tips of the tails following the lateral growth direction. Add a bit of lateral growth direction lines with a dirty brush on the largest of the tail feathers. Streak in shaft lines where needed using dirty white. Chop in a little dirty white feathering for texture on the bronzy rump, following the growth direction.

Separate the primary and secondary feathers with chisel-edge lines of dirty white, laid on top of graphite lines at the edge of each feather. Separate the far wing covert with dirty white highlights.

Soften markings on the back and scapulars by tapping or pushing some of the paint into the wet surface. The blue-throated hummingbird is not highly iridescent and as such these markings are more for color than flashy brilliance.

Chop the colors on the belly to create texture, then flip a few light feathers over the side of the green back.

Highlight the eye ring with Titanium White. Subdue the color on the throat by pressing it into the background paint if needed. Blend the edge of the throat into auricular area and connect to adjacent white. Add a few highlights to the crown with the highlight mix + more Titanium White. Highlight the beak with a dirty brush + Titanium White.

For the columbine, slightly blend the petals and buds with the chisel edge of a brush where the values meet. Highlight with the light mix + Titanium White if needed or desired on a few petals. Add dots of Titanium White at the tips of most of the stamens. On the stem, blend with growth direction where the values meet. Highlight with the green mix from Step 2 + more Titanium White and reblend.

Bluebird

LIAN ZHEN

MEDIUM: *Watercolor*

COLORS: **Winsor & Newton Artists' Water Colour:** *Antwerp Blue* • **Da Vinci:** *Naphthol Red Mid-Tone* • *Arylide Yellow*

BRUSHES: *nos. 2, 6 and 10 rounds • ¾-inch (19mm) flat*

OTHER SUPPLIES: *140-lb. (300gsm) cold-pressed Arches watercolor paper, 10" × 14" (25cm × 35cm) • no. 2 pencil*

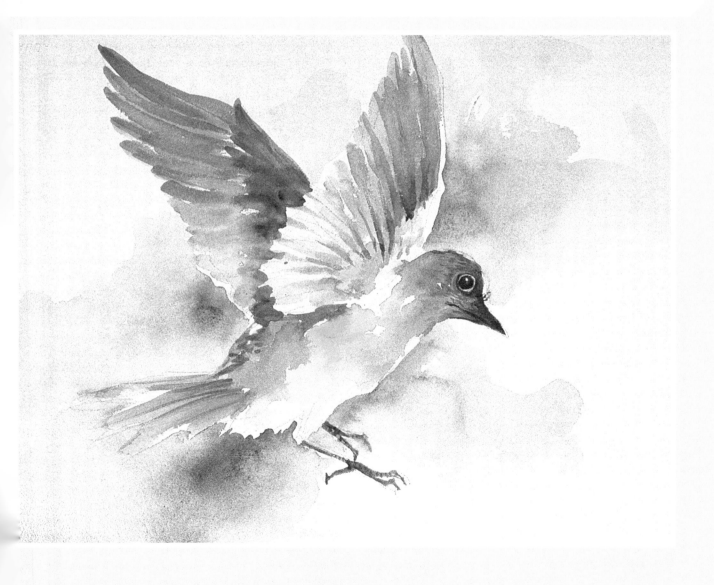

Bluebird

1 Sketch and Paint Face, Stomach

Lightly sketch the bluebird with a no. 2 pencil. Use a no. 6 round to mix Naphthol Red Mid-Tone and Arylide Yellow to create an orange color. Paint the face, chest and the beginning of the wing. Then use the brush to blend the colors into the stomach, tail and thigh areas with a little water.

artist's comment

Here are some helpful tips for Chinese watercolor painting:

1. After loading three or four pigments on one brush, dab the brush on the palette a few times to let the pigments blend into each other lightly.
2. Use strokes economically.
3. Control the amount of water on the brush.
4. Try not to change or correct strokes. It is better to throw away the paper and start over.

2 Apply Blue

Use the same brush to paint the head, back and tail feathers with Antwerp Blue. Lightly apply a little Antwerp Blue to the chest.

3 Paint Feathers

Use a no. 10 round to paint the wing feathers with Antwerp Blue mixed with a little Naphthol Red Mid-Tone. Each brush stroke paints one primary feather.

4 Define Wings, Beak, Feet

Use a no. 2 round to mix Antwerp Blue and Naphthol Red Mid-Tone into a dark blue to define the wing and tail feathers and outline the beak and eye. Mix Naphthol Red Mid-Tone and Antwerp Blue into a light pinkish blue to paint the feet.

5 Paint Final Details and Background

Use the no. 2 round to mix Antwerp Blue and Naphthol Red Mid-Tone into dark blue to paint the pupil and refine the texture of the feet. Use the same brush to paint the eyeball with Naphthol Red Mid-Tone on the upper portion and the Arylide Yellow on the lower portion. Blend the colors where they meet. Finally, paint the background to define the shape of the bird: Use a ¾-inch (19mm) flat to paint the background with the Antwerp Blue and a little Naphthol Red Mid-Tone first, then add a few drops of Arylide Yellow.

4

5

Cardinal

VICTORIA LISI

MEDIUM: *Watercolor*

COLORS: **Winsor & Newton Artists' Water Colour:** *Winsor Yellow • Quinacridone Red • Scarlet Lake • Perylene Maroon • Ultramarine Blue • Lamp Black*

BRUSHES: **Winsor & Newton Cotman Series III:** *nos. 4 and 6 round •* **Winsor & Newton Kolinsky Miniature Series 7:** *nos. 00 and 2*

OTHER SUPPLIES: *Winsor & Newton 140-lb. (300gsm) cold-pressed watercolor paper • Derwent Graphic no. H pencil • masking fluid • crow quill pen • stylus or old brush • dish soap • gray scale • soft eraser or masking fluid remover • paper towels • hair dryer (optional)*

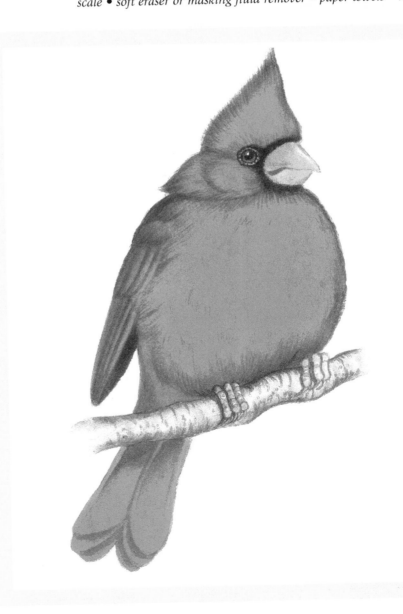

1 Create Drawing

Carefully draw the cardinal on watercolor paper. It's okay if you dent the paper slightly. This will create a funnel that will keep the paint contained.

Mix masking fluid with water (1:1). Mix dish soap with water (1:1) To prevent gumminess, always dip your stylus or pen in a dish-soap mixture before you dip it into the masking fluid.

2 Apply a Light Underpainting

Apply the masking fluid to any part of the cardinal you want to keep white. Use the stylus for the eye and beak glints and use the crow quill pen for the feathers. Let dry thoroughly.

Mix Winsor Yellow to a thin, watery consistency. Using the no. 6 round, wash Winsor Yellow over the body of the bird, including the eyes and beak. Omit the feathers and branch. Always let your paint dry completely between stages and steps; otherwise, you will either get water marks or one color will bleed into another. You can use a hair dryer, but if you use masking fluid, keep the dryer back about 12 inches (30cm) from the paper.

Mix a range of consistencies of Perylene Maroon with water from very watery to buttery. Restate the drawing and shadows with the maroon paint using the no. 2 and no. 4 rounds. For precise strokes, use wet paint on dry paper. For softer areas such as the shadows on the branch, wet the paper first then brush on the wet paint (i.e., wet-into-wet).

artist's comment

A yellow glaze underneath a painting adds brilliance and luminosity. It's useful when you want warm, vibrant colors and rich darks.

1

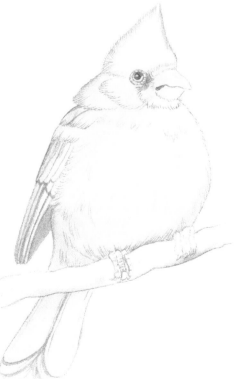

2

Cardinal

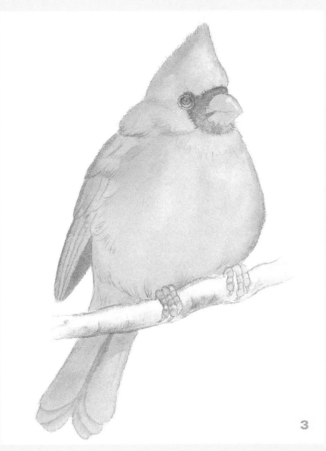

3

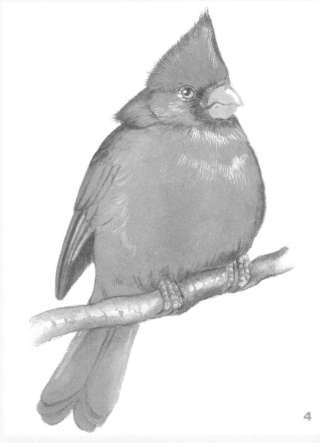

4

3 Glaze Body and Details

Mix a flowing Quinacridone Red + Scarlet Lake (1:1). With a no. 6 round, wash this mixture over the cardinal's body, avoiding the eyes, beak, feet and branch. Brush some Perylene Maroon with a flowing consistency into the wet paint as you go to create shadows. Work in one small area at a time: head, feet, etc. Let dry, then repeat this process to get rich color.

Mix Winsor Yellow + Scarlet Lake (1:1) to make orange. Use the no. 4 round to wash a watery mixture over the cardinal's beak. Use the no. 2 round to glaze the iris of the eye. Add a bit of Perylene Maroon and glaze over the feet with the no. 4 round.

Mix Ultramarine Blue and Quinacridone Red (1:1) to make purple. Glaze a watery mix over the dark feathers around the beak and the rim of the eye with a no. 2 brush.

Use the same mixture over the branch, painting wet-into-wet with a no. 6 round.

4 Add More Glazing

Glaze the cardinal's body with a flowing Quinacridone Red + Scarlet Lake (1:1) and a no. 6 round.

Restate shadows with a purple mix of Ultramarine Blue + Quinacridone Red (1:1) and nos. 2 and 4 rounds. Make your brush splay by wiping the paint-laden brush on a paper towel. Use the splayed edge to indicate feathers.

When the cardinal is dry, remove all masking fluid with a soft eraser or masking fluid remover.

The quality and characteristics of your splayed marks will vary depending on the amount of water you use.

DETAIL OF HEAD

1 Drawing

Here is the drawing with masking fluid applied using a crow quill pen and stylus. I added color to the masking fluid so it would show for the demonstration. Don't do this on your work as it will stain. Be sure to water down the masking fluid until it flows easily.

2 Splayed Brush Marks

Add splayed brush marks in Perylene Maroon to create detail for the feathers. Create splayed brush marks by loading the brush with paint and then wiping it over paper towels or a damp sponge before applying it to the watercolor paper.

3 Underpainting

Add an underpainting and initial glazes of Winsor Yellow and Quinacridone Red for a luminous effect.

4 Finished Head

Repeat the glazes of Quinacridone Red and Scarlet Lake and restate the splayed brush marks with Perylene Maroon, darkening them around the beak. Use a no. 00 brush to paint the smallest details.

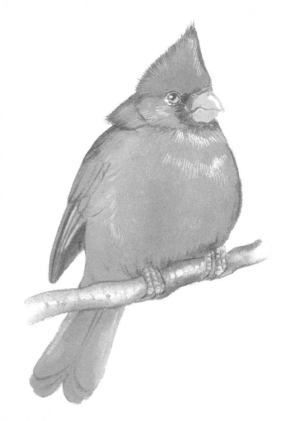

5 Add Finishing Touches

To make the white feather marks blend in, mix Quinacridone Red to a watery consistency and glaze over all the red feathers on the cardinal with a no. 6 round. With a no. 2 round, carefully go around the white areas where masking fluid was removed—on the eyes and beak—with the appropriate color. Deepen glazes and add detail as appropriate. Use a gray scale to see if you need deeper values. Mix some Lamp Black to a creamy consistency and use a no. 2 brush to paint the darkest feathers, pupil and details around the eyes.

Winsor Yellow

Quinacridone Red

Scarlet

Perylene Maroon

Glazing colors on top of each other creates colors that cannot be achieved by mixing paint on a palette. You can see the different effects Winsor Yellow and Perylene Maroon have on Quinacridone Red and Scarlet Lake.

Blue Jay

JANE MADAY

MEDIUM: *Acrylics*

COLORS: **Plaid FolkArt Artist's Pigments:** *Raw Umber • Cobalt Blue • Payne's Gray • Pure Black • Titanium White* • **Plaid FolkArt Acrylic Paint:** *Cayman Blue*

BRUSHES: **Silver Brush Ultra Mini Designer Rounds:** *nos. 4, 6 and 12 (You will need to use smaller rounds if you use another brand.)*

OTHER SUPPLIES: *Cold-pressed Canson Montval watercolor paper • Masterson Sta-Wet Palette • water container • masking fluid (optional)*

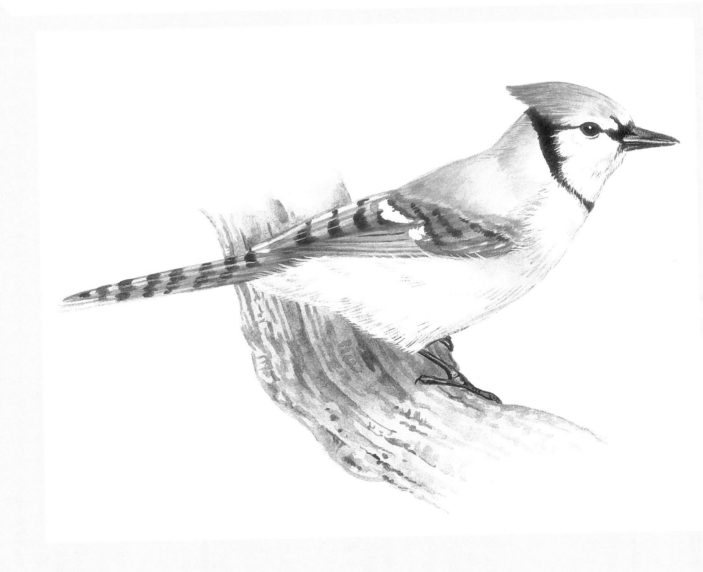

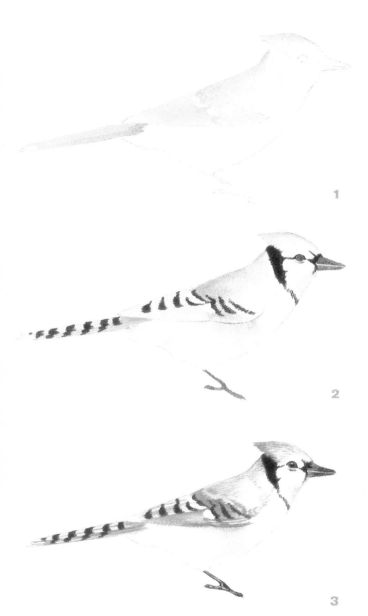

1 Apply Blue Washes

If desired, protect the white spots on the wings with masking fluid. Basecoat the head and back with a thin wash of Cobalt Blue and the no. 12 round. Let the color fade as you approach areas that will remain white. Apply to the wings and tail a wash of Cayman Blue. Add another thin wash of Cobalt Blue along the bottom edge of the tail.

2 Shade and Add Black Markings

Paint the eye, beak and legs with Raw Umber + Payne's Gray (1:1) and a no. 4 round. Add the black markings with Pure Black and a no. 4 round. Shade the breast and neck with very thin Raw Umber and the no. 6 round.

3 Develop Features

Develop the blue feathers with Cobalt Blue thinned to a creamy consistency and the no. 4 round. Glaze a little Raw Umber along the wing. Add a pupil to the eye and develop the beak and legs with Pure Black. Highlight the eye and legs with a dot of Titanium White. Remove the masking fluid.

4 Paint Branch, Detail Blue Jay

(See finished painting on page 78.) Paint the branch with a thin wash of Raw Umber and the no. 12 round. Let dry. Glaze a Payne's Gray shadow on the branch and detail with Raw Umber.

Glaze thin Cayman Blue over the blue jay's back with the no. 6 round. With the no. 4 round, detail the wings and tail with Payne's Gray. Paint Raw Umber details on the white areas. Finally, paint a few Titanium White feather strokes overlapping the wing, tail and leg.

artist's comment

A regular visitor to my aunt's and uncle's bird feeder is a blue jay they call "Picky Pete." He very carefully lifts each peanut shell before flying away with the heaviest one! Blue jays can be pushy at the feeder, chasing away smaller birds. It's a good thing they are so lovely, otherwise they might not be welcome in my yard!

Dilute all the paint for this project with water and paint in a washy, watercolor manner. "Glaze" means to paint a thin wash of one color over another dry color.

Mockingbird

Elizabeth Golz Rush

MEDIUM: *Watercolor*

COLORS: **Winsor & Newton Artists' Water Colour:** *Yellow Ochre • Burnt Sienna • Burnt Umber • Permanent Sap Green • Ultramarine Blue • Cadmium Scarlet • Neutral Tint*

BRUSHES: *nos. 2, 5 and 7 round (I recommend Winsor & Newton or Isabey.)*

OTHER SUPPLIES: *90-lb. (190gsm) Arches watercolor paper • tracing paper • nos. 2B and HB pencils • soft white eraser • masking tape • paper tape • water container • sectioned dish for mixing watercolor washes • tissues (plain, not lotion-treated) • white scrap paper for color testing and unloading extra paint from brush • small natural sponge (optional) • lightbox (optional)*

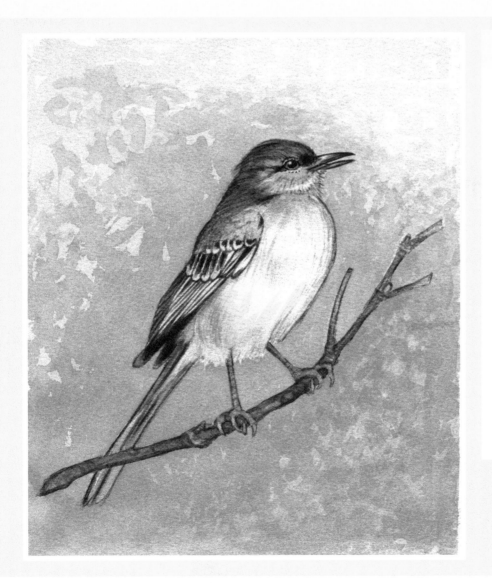

artist's comment

Paint light to dark. Develop your watercolor by starting with light colors first, in flat color washes. Start with your largest brush and paint in sections, allowing each to dry before adding more color or painting neighboring sections. Make your paint strokes flow in the same direction as the bird's feathers. Also, use the "drybrush" technique to suggest tiny feathers and delicately add more color and definition. To "drybrush," dip you brush into your color wash and then paint onto your scrap paper until the brush holds very little paint and begins to fan out a bit. Now use the fanned brush to indicate little feather patterns and delicate shading.

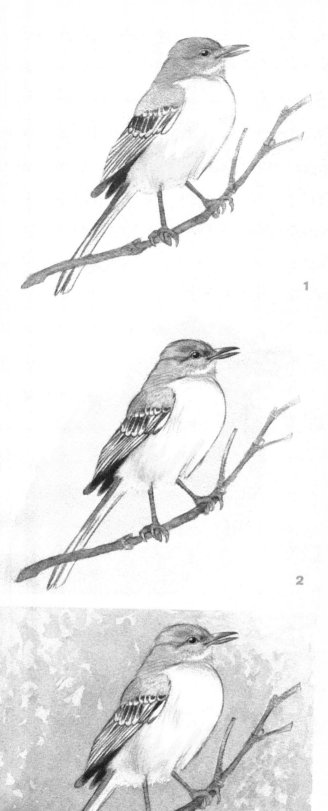

1

2

3

1 Create Sketch and Apply First Washes

Develop your drawing thoroughly, because changes and corrections will be more difficult to make later. Relax and explore—use your eraser! Use tracing paper to "build" your drawing. When you're satisfied with the drawing, transfer it to the watercolor paper using a window in daylight or a light-box. Draw lightly and try to keep the paper clean and free from smudges. When finished, tape your watercolor paper onto smooth, heavy cardboard or board.

Start with a light wash of Yellow Ochre and the no. 7 brush. Use this wash to shade under the bird's wing and between its legs. Brush this wash on the head with varied strokes. Use a no. 5 round to begin to define feathers in the chest, head and under the chin. Use the no. 2 round to paint areas around the eye and beak. Paint the branch using the Yellow Ochre wash. Make a very pale wash of Neutral Tint or make your own gray/black using a mixture of Burnt Umber and Ultramarine Blue. Paint the solid pale areas of the bird's head and upper wing. Use a no. 2 round to paint the legs and feet, and to start to define the tail and wing feathers.

2 Add Detail

Thicken the Neutral Tint wash and use the no. 2 round to paint wing feathers and tail outlines. Delicately outline and add details to the bird's legs and feet, but keep the coverage light. Continue to darken your wash as you paint the details, with the shadows under wings becoming a strong dark charcoal. Carefully paint the bird's pupil using the same dark tint, leaving a little unpainted circle. (This highlight gives life to the eye.)

When the branch is dry, begin defining the shading and textures with the Yellow Ochre wash, gradually adding a little Burnt Umber to darken the wash. Add a light touch of Permanent Sap Green around the branch buds.

3 Paint Background

Make a light wash of Ultramarine Blue for the background area and apply it with varied strokes or a natural sponge for texture. Don't worry if you run out—this dappled background is forgiving and allows for successive layers of painting.

4 Add Final Details

(See finished painting on page 80.) Paint a little more feather detail on the bird's chest using Yellow Ochre mixed with a touch of Burnt Sienna. Add a tiny bit of very pale Cadmium Scarlet to the beak and inside the mouth. Complete the painting using the no. 2 round and the darkest color washes to delicately outline the bird's beak, strengthen lines that define volume (such as the bird's chest) and add tiny details.

Painted Bunting

JANE MADAY

MEDIUM: *Watercolor*

COLORS: **Daler-Rowney Artists' Water Colours:** *French Ultramarine • Cadmium Yellow Hue • Hooker's Green Light 1 • Payne's Gray • Cadmium Red Hue • Raw Umber • Burnt Umber • Burnt Sienna • Titanium White • Yellow Ochre*

BRUSHES: **Silver Brush Ultra Mini Designer Rounds:** *nos. 4 and 6 (You will need to use smaller rounds if you use another brand.)*

OTHER SUPPLIES: *Cold-pressed Canson Montval watercolor paper • palette • water container*

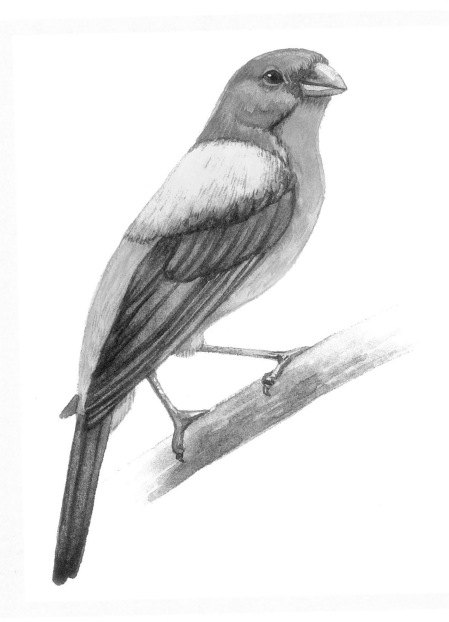

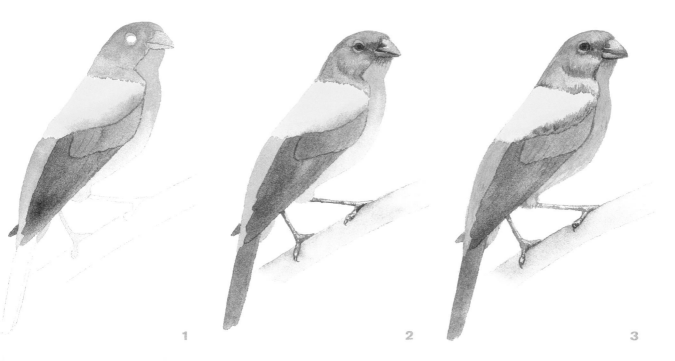

1

2

3

Paint the Basecoat

Use the no. 6 round to basecoat the head with French Ultramarine. Paint a wash of Cadmium Yellow Hue on the back. While the wash is still wet, add Hooker's Green Light 1 as shown, letting it blend. Paint the beak and legs with Payne's Gray. Paint the breast, back and eye rim with Cadmium Red Hue. Mix Hooker's Green Light 1 + Raw Umber (2:1) and paint the wing feathers. Add more Raw Umber to the mix for the bottom of the wing.

Paint Beak, Legs and Eye

Paint the tail with Burnt Umber + Hooker's Green Light (1: touch). Paint the twig with a wash of Raw Umber. Paint the eye with a darker concentrate of Raw Umber. Paint a glaze of Yellow Ochre across the red back, the underside of the tail and the belly using the no. 6 round. Use the no. 4 round (or smaller) to detail the beak, legs, eyes and head with Payne's Gray. Add a little Raw Umber near the beak.

3 Add Dark Details

Add a little more French Ultramarine to the shaded parts of the head. Detail the breast, belly and back with Burnt Sienna. Glaze Cadmium Red Hue on the tail, and add red feathers to the top of the wing, still using the no. 4 round. When the red is dry, add a little French Ultramarine above it.

4 Add Final Details

(See the finished painting on page 82.) Paint highlights on the eye and beak with Titanium White using the no. 4 round. Mix Hooker's Green Light 1 + Raw Umber and add details to the wing. Detail the tail with Burnt Umber + Payne's Gray (1: touch). Mix Raw Umber + Payne's Gray (1:1) and shade the twig.

artist's comment

The painted bunting (also called the "nonpareil") lives in the southern United States. This painting shows the male of the species. The female is green.

House Sparrow 1

KAY SMITH

MEDIUM: *Watercolor*

COLORS: **Daniel Smith:** *Deep Scarlet • Quinacridone Gold • Quinacridone Burnt Orange • English Red Ochre • **American Journey:** Sepia • Midnight Blue*

BRUSHES: **Pro Arte Prolene:** *no. 2 rigger • **CJAS Golden Fleece:** no. 8 round*

OTHER SUPPLIES: *140-lb. (300gsm) cold-pressed Saunders Waterford watercolor paper*

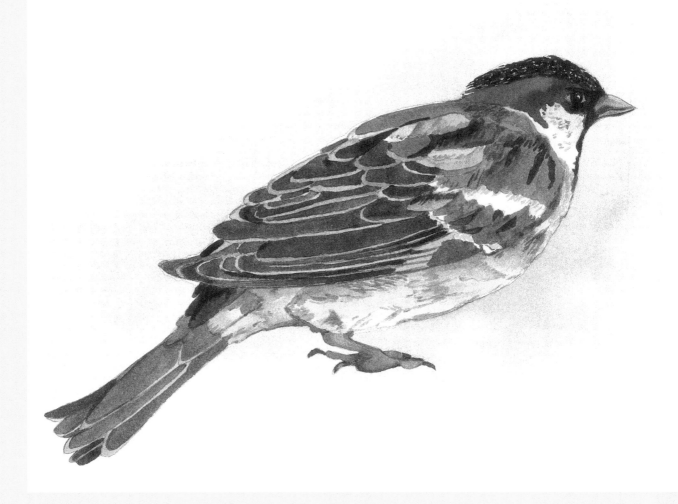

SONGBIRDS

84

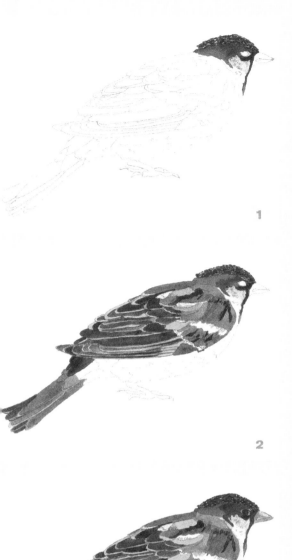

1

2

3

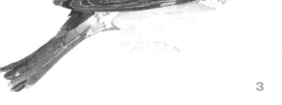

1 Paint the Head Feathers

Sketch the house sparrow. Wet the bird's crown with a no. 8 round. Load Sepia + Deep Scarlet (1:1) on the same brush. Make tiny stipple lines resembling feathers on the crown, leaving some white showing. Repeat with straight Sepia. Smooth this brindled area with a clean, damp brush to soften the edges. With the same brush, paint under the crown around the eye with Sepia + Deep Scarlet + English Red Ochre (1:1:1). Paint the area between the crown and beak, under the beak and eye, and at the top of the breast with straight Sepia. Make tiny feather lines in the white area under the eye with the tip of a no. 8 round and thinned English Red Ochre + Sepia (1:1). Leave white paper at the breastbone area. Let dry. Create a cast shadow under the eye area using thinned Sepia.

2 Paint the Wings and Tail Feathers

On dry paper, apply warm reddish tones to the top right wing and middle wing feathers with Quinacridone Burnt Orange + Deep Scarlet (1:1) and the no. 8 round. Leave the tips white. Paint the top wing feathers with Quinacridone Gold and use this color on the wing tips and outlines. Use Sepia and the no. 2 rigger to paint tiny dark feathers. You can add a small amount of Quinacridone Burnt Orange to Sepia to warm the color. Under the wing area, apply Sepia where the tail feathers begin, using either brush. Under that area, dilute Sepia + Quinacridone Burnt Orange (1:1) for warm brown tones, leaving the edges light. Glaze these light edges with Quinacridone Gold.

3 Paint the Breast, Eye and Beak

Lightly wet the white breast and under the tail feathers with a no. 8 round. Lay in thinned Sepia to show shadows and feather separations. Paint the eye using Sepia + Midnight Blue (1:1) on a no. 2 rigger. Leave a tiny white highlight. Let dry. To paint the beak, use Sepia + Midnight Blue + Quinacridone Burnt Orange (1:1:1). Leave the top of the beak lighter. To scrub out a light area, use a small bristle brush (for oil painting), a clean toothbrush, or simply lift out the paint with a damp watercolor brush. Paint around the eye socket with thinned Sepia on the no. 2 rigger.

4 Paint Feet, Legs, Background

(See the finished painting on page 84.) With the no. 2 rigger, mix Quinacridone Gold + Quinacridone Burnt Orange (1:1) and paint the legs and feet. Use Sepia to paint the delicate talons. Adjust any areas that need stronger values with additional glazing. For the sky background, wet the paper around the bird's body with a no. 8 round. Dip the brush into a thinned puddle of Midnight Blue and apply it very wet, allowing paint to flow and mix freely with the wet paper. Add tiny rigger lines to the Quinacridone Gold back and wing feathers. Adjust values on the beak to make them darker if needed.

artist's comment

Work from the top downward when drawing or painting. This method keeps your paper and your hands clean, and allows your thoughts and plans to flow in a logical sequence.

House Sparrow 2

LIAN ZHEN

MEDIUM: *Chinese watercolor*

COLORS: ***Chinese painting colors or sumi colors:*** *yellow • Burnt Sienna • white*

BRUSHES: ***Chinese brushes:*** *extra small • small • medium*

OTHER SUPPLIES: *Raw Shuan paper (unsized rice paper), 8" × 10" (20cm × 25cm) • Chinese painting ink or sumi ink*

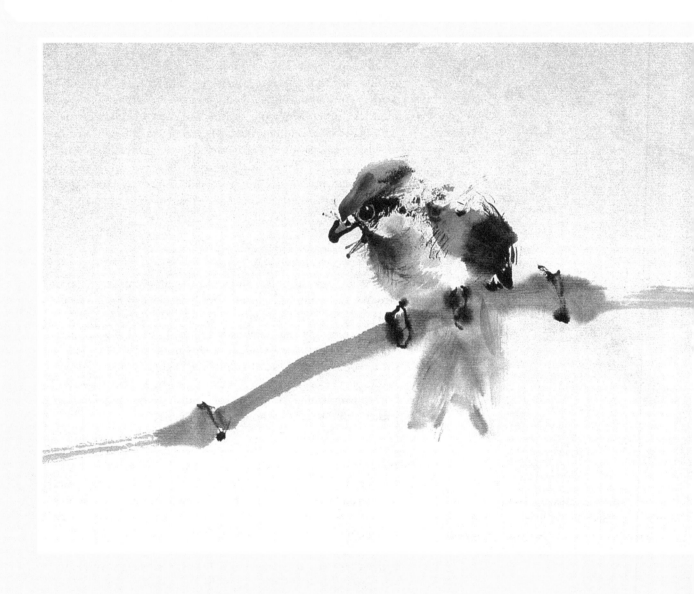

1 Paint Head and Wing

Use a small brush and load a little yellow on its heel and Burnt Sienna on the middle and tip. Add a little ink to the tip as well. Hold the brush sideways to paint one stroke on the head, then paint a larger stroke for the wing. The brush should be almost out of color and water. Split the brush tip with your fingers to paint the feathery effects on the face, head and wing.

2 Paint Beak, Eye, Feathers

Use an extra small brush and a little intense ink to paint the beak, eye and feathery effects. Make sure the brush contains only a little ink and water, otherwise the ink will blend too much.

3 Paint Chest and Tail

Use a medium brush and load white onto its heel, a little Burnt Sienna on the middle and tip, and intense ink on the tip. Hold the brush sideways with the tip pointing to the beak to paint a couple of strokes for the chest. Use the small brush to paint the tail with light ink and Burnt Sienna.

4 Paint Branch and Feet

(See the finished painting on page 86.) Paint the bamboo branch with the medium brush and light ink. Before it dries, use the extra small brush and intense ink to paint the black feather on the wing and the feet.

artist's comment

Here are some helpful tips for Chinese watercolor painting:

1. After loading three or four pigments on one brush, dab the brush on the palette a few times to let the pigments blend into each other lightly.
2. Use strokes economically.
3. Control the amount of water on the brush.
4. Try not to change or correct strokes. It's better to throw away the paper and start over.

Wren and Sunflower

ELIZABETH GOLZ RUSH

MEDIUM: *Watercolor*

COLORS: *Lemon Yellow • a warm yellow (like Winsor & Newton's New Gamboge) • Yellow Ochre • Burnt Sienna • Raw Umber • Sap Green • Hooker's Green Dark • Ultramarine Blue • Cadmium Scarlet • Magenta*

BRUSHES: *nos. 2, 5 and 7 rounds*

OTHER SUPPLIES: *90-lb. (190gsm) Arches watercolor paper • tracing paper • nos. 2B and HB pencils • soft white eraser • masking tape • paper tape • water container • sectioned dish for mixing washes • plain tissues for blotting or light spills • white scrap paper • lightbox*

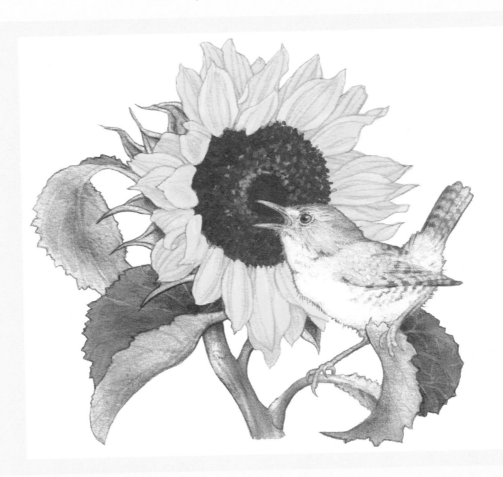

artist's comment

Develop your watercolor by starting with light colors first, in flat color washes. Start with your largest brush and paint in sections, allowing each to dry before adding more color or painting neighboring sections. Make test strokes on scrap paper after loading paint on your brush to control the amount of paint in the brush and evaluate the color.

1 Create the Sketch

Develop your drawing thoroughly because changes and corrections will be more difficult to make later. Relax and explore! Use tracing paper to "build" your drawing. Start with a rough, loose sketch using a no. 2B pencil. Then, place another sheet of tracing paper on top and trace what works, correcting and refining the drawing in successive layers. I suggest drawing the flower and the bird on separate layers, which allows for easy repositioning.

Transfer your drawing onto lightweight 90-lb. (190gsm) watercolor paper using a window in daylight or a lightbox. Tape your tracing paper drawing onto the glass and cover with the watercolor paper. If it's taped down tightly, you should be able to see your drawing clearly. Use a very sharp no. HB pencil to trace the outlines and important elements of the drawing on the watercolor paper. Draw lightly and try to keep the paper clean and free from smudges. When finished, tape your watercolor paper onto smooth, heavy cardboard or workboard.

2 Paint the Bird and Sunflower

(See the finished painting on page 88 for the sunflower details.) Create a light wash of Lemon Yellow and paint all the sunflower petals. When the yellow section is dry, paint all the leaves with a light wash of Sap Green.

Mix a very pale wash of Yellow Ochre and Burnt Sienna and paint the entire bird except for the feet and extended leg. While the paint is still wet, use clean tissue to blot and lighten the bird's chest and beak. Now add more Burnt Sienna to darken the wash. Using a no. 5 round, continue to lightly paint the bird's head, wing and tail, and begin to darken and define the wing shading and feather patterns. Your brushstroke should follow the direction of the bird's feathers. Use the drybrush technique to suggest tiny feathers and to deli-

cately add more color and definition. To drybrush, dip your brush into a color wash and then paint onto scrap paper until the brush holds very little paint and begins to fan out. Then use the brush on your painting.

Mix a medium wash of Burnt Sienna and paint in the dark center of the sunflower with a no. 5 round. Take your time and concentrate on the outline edges defining the bird's head and beak. This area has a lot of texture, so your wash does not need to be even—just keep the edges clean.

Adding successive layers of pale color washes is called glazing. Use this technique to detail the sunflower. Brush a light wash of Burnt Sienna or Yellow Ochre on the underside of the leaves. Use a very light Cadmium Scarlet wash to add color variety to some of the flower petals and a Magenta wash to the flower center, dabbing with a tissue in highlighted areas.

Use a warm yellow and the no. 5 round to define the flower petals and create shading. As you work, increase the color intensity by adding more paint to the wash. Use Yellow Ochre to outline petals and for stronger shadows.

Use increasingly darker and richer washes of Sap Green to paint the leaves, defining darker leaf tops and other shading. Glaze darker leaf areas with light washes of Hooker's Green Dark. For areas of very dark green, use Hooker's Green Dark + a little Ultramarine Blue. Darken and add texture to the flower center with small dabbing strokes of Burnt Sienna darkened with a little Raw Umber. Use the no. 2 round in the areas that define the bird's beak and petals.

Color the bird's leg, feet and beak with a light wash of Cadmium Scarlet + Yellow Ochre and outline and shade slightly with Raw Umber + Burnt Sienna. Add a touch of Ultramarine Blue to the outline color to paint details such as the bird's eye and shaded wing feathers, and the lines defining the leaf shadow edges. Use the no. 2 round to add final details.

Black-Capped Chickadee

JANE MADAY

MEDIUM: *Watercolor*

COLORS: **Daler-Rowney Artists' Water Colours:** *Payne's Gray • Raw Umber • Warm Sepia • Yellow Ochre • Ivory Black • Titanium White*

BRUSHES: **Silver Brush Ultra Mini Designer Rounds:** *nos. 4 and 6 (You will need to use smaller rounds if you use another brand.)*

OTHER SUPPLIES: *Cold-pressed Canson Montval watercolor paper • palette • water container*

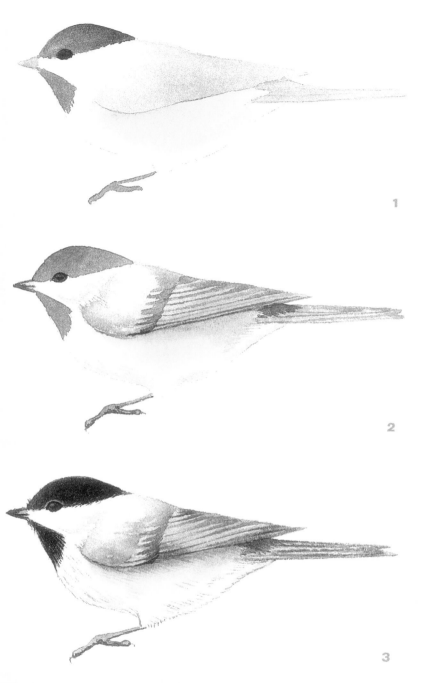

1 Paint the Base Colors

Using the no. 6 round, paint the head, chin patch, beak, wings, tail and legs with Payne's Gray. The paint should be thinner for the beak, wings and tail (let the wings dry before painting the tail). Paint the eye using Warm Sepia. Glaze thinned Yellow Ochre on the breast.

2 Add Details and Shading

With the no. 4 round (or smaller brush if you prefer), paint the pupil and outline of the eye with Ivory Black. Begin adding details to the beak, wings, legs and tail with Payne's Gray, using the paint slightly thicker than in your first washes. Add a little shading to the belly and cheek with thinned Raw Umber.

3 Detail Head, Add Raw Umber Glazes

Paint the head and chin patch with Ivory Black and the no. 4 round, leaving a lighter rim around the eye. Add glazes of Raw Umber to the beak, wings and tail. Paint a few feather strokes on the breast and belly, still using Raw Umber.

4 Add Final Details, Paint Branch

(See the finished painting on page 90.) Add a few Payne's Gray details to the wings and cheek. Finally, add Titanium White highlights to the eye and head, and paint a few white feather strokes on the breast and wings. Basecoat the twig with Raw Umber and the no. 6 round. Detail with Warm Sepia.

artist's comment

Chickadees are among my favorite birds, so I'm always happy to see them at my feeder. The American chickadee looks similar to its European cousin, but has a different call. As you paint, be sure to use thin glazes as this will create richer colors than if you paint one thick layer.

I like to use clean water to blend the edges of my washes. This gives them a soft appearance.

Waterbirds

The downy feathers, webbed feet and unusual beaks of waterbirds make them interesting painting subjects.

Mallard Duck

VICTORIA LISI

MEDIUM: *Acrylics*

COLORS: **Golden Fluid Acrylics:** *Bone Black • Manganese Blue Hue • Primary Yellow • Phthalo Blue (Green Shade) • Quinacridone Red • Red Oxide • Sap Green Hue • Titanium White • Ultramarine Blue*

BRUSHES: **Winsor & Newton Cotman Series III:** *nos. 1, 4 and 6 rounds •* **Winsor Newton Galleria:** *no. 0*

OTHER SUPPLIES: *140-lb. (300gsm) cold-pressed watercolor paper • acrylic paint retarder • masking fluid • red or graphite transfer paper • stylus or old brush • dish soap • gray scale or value finder • soft eraser or masking fluid remover • sketch or tracing paper*

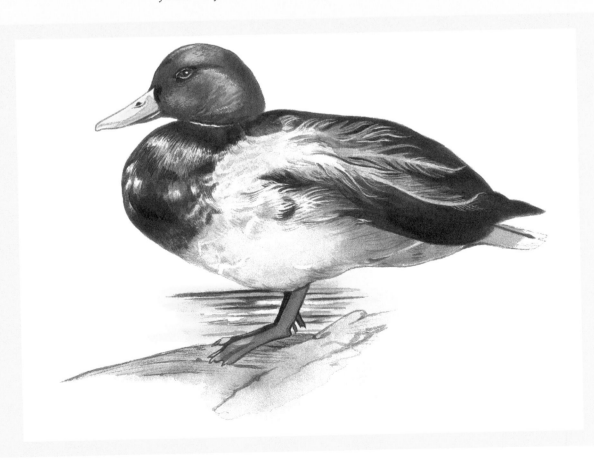

1

2

artist's comment

Always mix a drop of acrylic paint retarder with your paints. This will prolong the drying time. Mix varying amounts of water with your paint to vary the values:

- Watery: Lots of water for light values
- Flowing: Some water for medium values
- Creamy: Little or no water

Be sure to change your water frequently!

1 Apply Masking Fluid, and Yellow Glaze

Draw the mallard duck carefully on sketch or tracing paper. Transfer to watercolor paper using transfer paper. Prepare masking fluid + water (1:1) and water + dish soap (1:1).

Dip the stylus or old brush first in the soap mixture and then in the masking fluid mixture (it should flow easily). Apply masking fluid to the lightest areas on the duck—eye highlights, select feathers, etc. (see the finished painting as a reference). Let dry completely.

Mix Primary Yellow with enough water so it flows easily and use it to paint the darkest areas of the duck with a no. 4 round.

2 Apply Initial Underpainting

Mix Quinacridone Red and Phthalo Blue (2:1) to make purple. Add enough water so the mixture flows easily. Use this color and a no. 4 round to paint the darkest areas on the duck's head. Use wet paint on dry paper. Soften the edges with a little water as you go. Paint the darkest parts of the duck's upper body in the same manner.

The no. 4 round will splay as you use it. Use the splayed edge to drybrush feathers. Start with the wetter brush in the darker areas. As the brush dries and splays move it to the lighter areas. Always move your brush in the direction that the feathers flow. Make tiny, short feather marks on the duck's head, medium strokes on the belly and longer ones on the back.

Mix a medium shade of purple to a thin, watery consistency. Wet the duck's belly with water. While the paper is still wet use the no. 6 round to flow this purple mixture over the duck's belly, using the wet-into-wet technique.

Mallard Duck

3

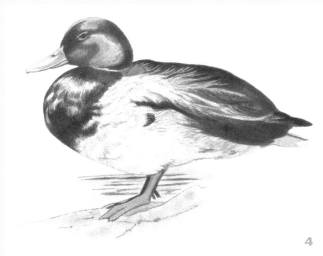

4

3 Finish Underpainting

Continue to work on the underpainting. Strive to create a full range of values, from white to very dark purple. (A gray scale will be useful here.) You may need to repaint the darkest areas several times to get them dark enough.

Use the no. 2 brush for small details. A finished-looking underpainting will create depth and set off the glazed color.

4 Add Color Glazes

Mix a watery Primary Yellow and glaze it over the duck's bill. Add a bit of Quinacridone Red to the yellow (1:2) and glaze the duck's feet.

Mix separate puddles of Phthalo Blue and Manganese Blue with water to a flowing consistency. Using the no. 6 round, wet the duck's head. Keeping the highlight in mind, use a no. 4 round to glaze the two different blues onto the wet paper, letting the colors blend on the paper. Go right over the purple underpainting. Wet the no. 4 round, squeeze the water from it with your fingers, and lift excess color from the highlight as needed.

· Mix two puddles of Red Oxide with water—one that is flowing and one that is watery. Keep the highlights in mind and leave them white. Use the no. 4 round to glaze the duck's breast with Red Oxide, using the thicker paint in the darker areas and the thinner paint in the lighter areas. Add some Ultramarine Blue to the Red Oxide (1:2) to make a dark brown. The consistency should be flowing. Using the no. 4 round, glaze over the darker parts of the breast and back. Always apply your strokes in the direction of the feathers.

Mix a watery Sap Green Hue. Wet an area that extends beyond the outer edges that will be painted as water. Use your no. 6 round to glaze the green paint into the wet paper. Let it feather into the wet edges. Wet the paper again for the driftwood, extending the water beyond the outer borders. Use the same dark brown you mixed earlier: Ultramarine Blue + Red Oxide (1:2) to a watery consistency. With your no. 6 brush, drop the dark brown unevenly into the wet paper, letting it feather at the edges.

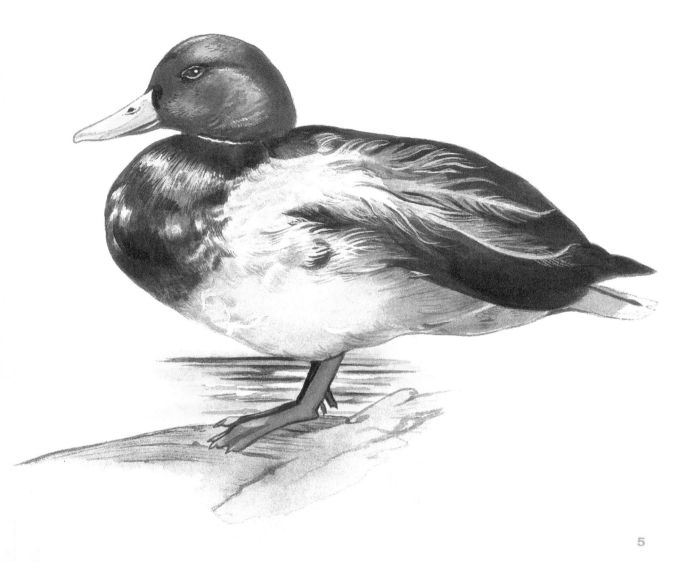

5

5 Add Final Details

Remove all masking fluid with an eraser. With a no. 2 brush paint the appropriate matching color along the edges of the whites left by the masking fluid. If the whites are too prominent, glaze over them with very thin, watery glazes of the appropriate color.

If necessary, deepen the glazes using the same colors and techniques as before. Use Titanium White straight out of the bottle (creamy) where necessary for highlights on feathers, water, eyes, etc.. using nos. 0 and 2 brushes. Use tiny amounts of creamy Bone Black in a few areas to strengthen the darkest darks.

Egret

CINDY AGAN

MEDIUM: *Acrylics*

COLORS: **Liquitex Soft Body:** *Titanium White • Cadmium Orange • Cadmium Yellow Medium • Raw Umber • Burnt Sienna • Mars Black • Indanthrene Blue*

BRUSHES: **Robert Simmons Expression Series E85:** *no. 3 round*

OTHER SUPPLIES: *140-lb. (300gsm) cold-pressed watercolor paper size 8½" × 10" (21cm × 25cm) • no. 3H pencil*

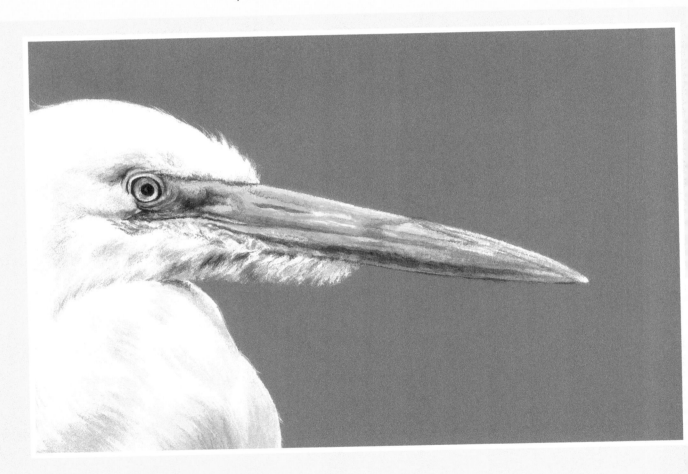

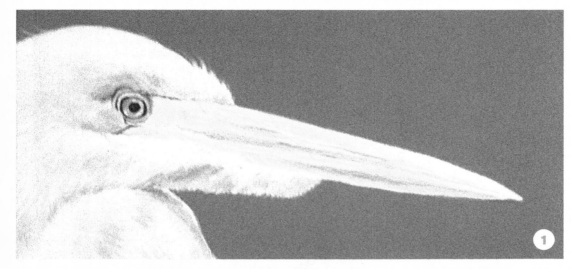

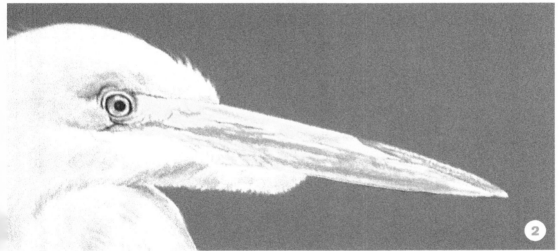

1 Lay the Foundation

Sketch the bird in detail with a no. 3H pencil. To establish the base color on the bill, create a mix of Titanium White + Cadmium Yellow Medium (2:1) and paint the lighter values. Next, indicate the nostril, the shadows and where the upper and lower bill separate with a mix of Cadmium Orange and Burnt Sienna (1:1)

2 Add a Range of Values

Apply a mix of Titanium White + Indanthrene Blue (2:1) under the eye and on the end of the upper bill. Add highlights to the bill with Titanium White to create the lightest value. For a medium-value color add a few details using Cadmium Orange. Define the nostril, creases and grooves in the bill with Burnt Sienna as a darker value.

artist's comment

A white subject, such as this egret, might be hard to "find" on a white piece of paper or canvas because it tends to blend into the background. To remedy this, paint the background a darker value to allow the subject to stand out and be noticed.

Egret

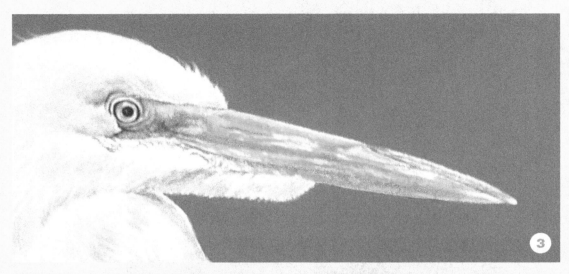

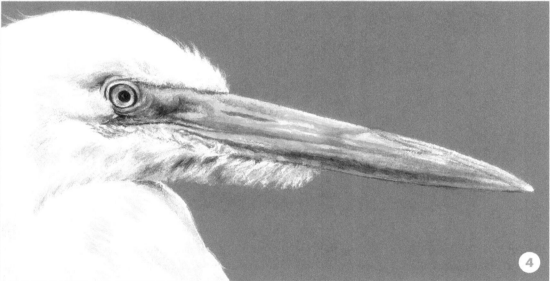

3 Create Depth

Drybrush Raw Umber in the areas close to the eye, under the chin and the perimeter around the bill. Apply a thin glaze of Raw Umber to deepen the shadows and to tone down some of the brighter areas to create a sense of depth. Use all of the colors and mixes from the previous steps to blend and soften the surrounding areas. The bill is thick and rough, so give it texture by occasionally dragging your brush over an area. Continue to add creases and grooves.

4 Add Final Details

With Raw Umber and/or Burnt Sienna continue to tone down any areas that still appear too bright. Apply a thin glaze of Mars Black over the deepest values. Change the focus now and concentrate on painting the "transition" from bill to feathers. Alternate blending between the following two mixes: a gray mix of Titanium White + Mars Black (2:1) and a light-blue mix of Titanium White + Indanthrene Blue (2:1). Finish with a few highlights in the feathers with Titanium White.

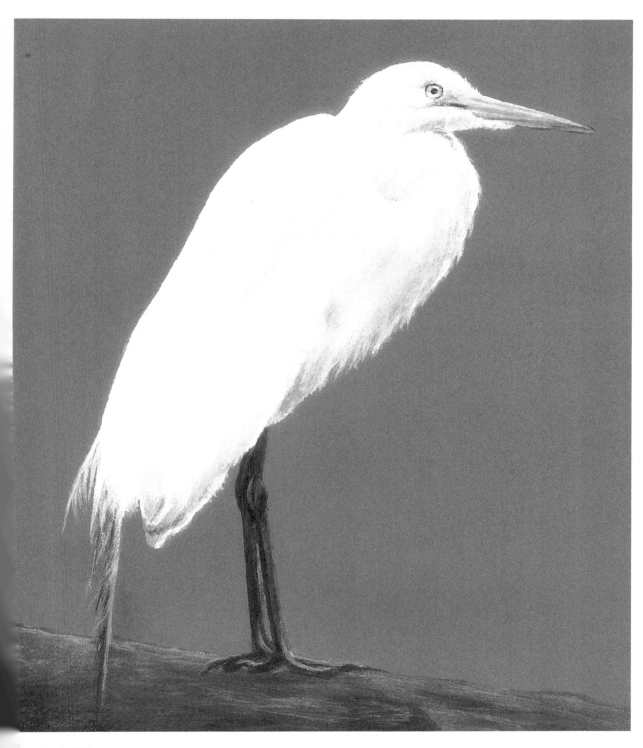

Egret in Full View

In this full-body painting of an egret, the bird is shown from a distance and the details are not seen as clearly as in the close up demo. So make it easy for yourself and remember, if you cannot see it, you don't need to paint it!

Seagull

CLAUDIA NICE

MEDIUM: *Watercolor*

COLORS: **M. Graham & Co. Watercolor:** *Payne's Gray • Cobalt Blue • Cadmium Orange • Gamboge • Quinacridone Rose • Burnt Sienna*

BRUSHES: *nos. 4 and no. 6 round sable watercolor (Use the large brush to paint large areas and the small brush for smaller areas.)*

OTHER SUPPLIES: *140-lb. (300gsm) cold-pressed watercolor paper (artist grade)*

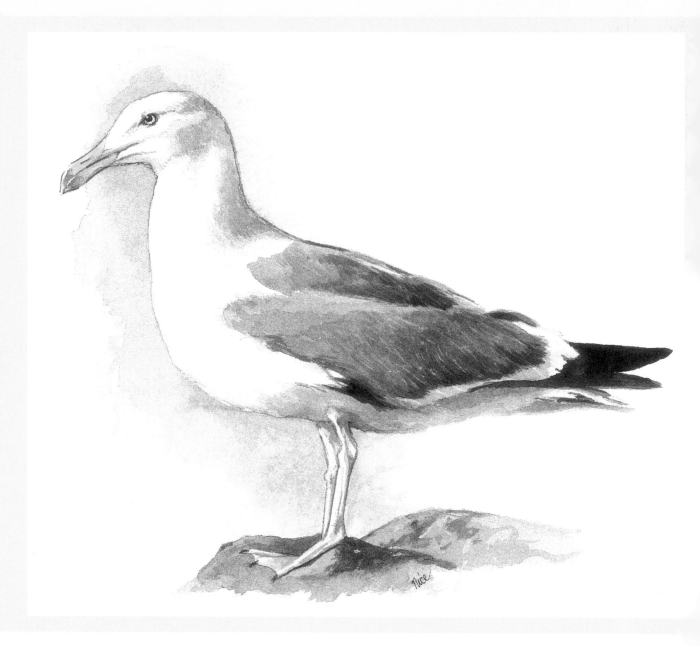

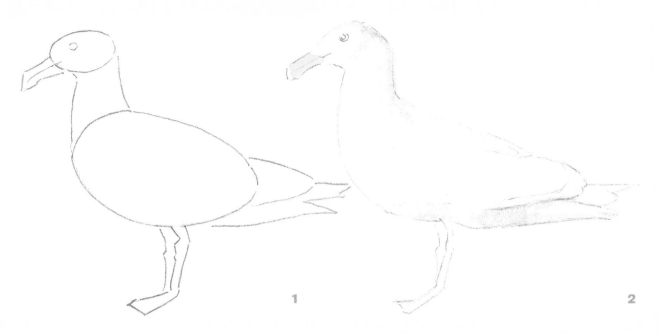

1

2

Color References

In this demonstration, colors and color mixtures are identified by a letter. Refer to this chart to find the correct color.

A. Payne's Gray
B. Payne's Gray/ Cobalt Blue
C. Payne's Gray/Cadmium Orange
D. Gamboge
E. Cadmium Orange
F. Quinacridone Rose/Burnt Sienna
G. Quinacridone Rose/Burnt Sienna + a touch of Payne's Gray

1 Draw Basic Sketch

Sketch the seagull with a pencil. Note that seagulls and most other birds are made up of two basic shapes. An egg shape forms the body (with the wider part of the egg at the breast), and the head is an oval.

2 Apply Basic Washes

Begin brushing on the basic watercolor washes. A wash is a mixture of paint and lots of water to keep it light and fluid. Dampen the area you will be working on before starting. Make sure the paper is just damp, not wet. Blot extra moisture if necessary. The beak is yellow (D). The upper back, neck, head and lower wing strip are gray mixture (B). The belly, tail and iris of the eye are gray mixture (C). The legs are rose mixture (F). Before the gray shadow areas dry, soften the edges by stroking along them with a clean, damp brush. Rinse and blot the brush often to prevent the colors from spreading.

Seagull

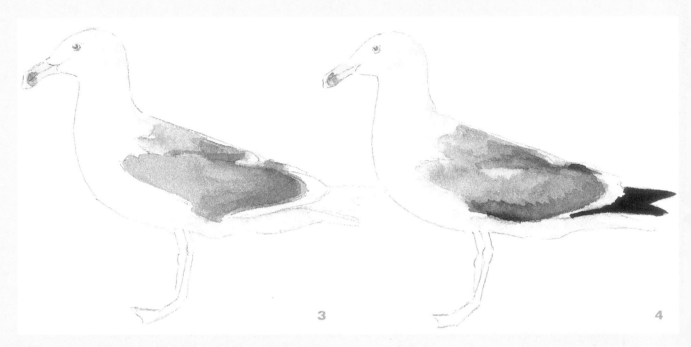

3

4

3 Add Payne's Gray Wash

The back and wings are painted with a wash of Payne's Gray. Add a smudge of the same color at the end of the beak. Let the paint dry completely.

4 Add Glazes

Add a dot of rose mixture (F) behind the smudge on the beak (refer to the close-up at right). Soften the edges.

Add a glaze of Payne's Gray (A) over the shadow areas of the back and wings as shown. A glaze is a thin wash of paint that is painted over a dry, previously painted area to add more pigment. Add as many glazes as needed to form a nice shadow. Be sure to let the paint dry between applications.

Paint the tail and the pupil of the eye with a medium-heavy coat of Payne's Gray. Be sure to leave the highlight in the eye white. If it is filled in accidentally, let it dry and scrape in a new highlight with the edge of a razor blade.

5 Shade Beak

Shade the beak area around the red dot with Cadmium Orange. Let dry. Shade the rest of the beak and around the eye with a wash of the rose mix (G) as shown.

5

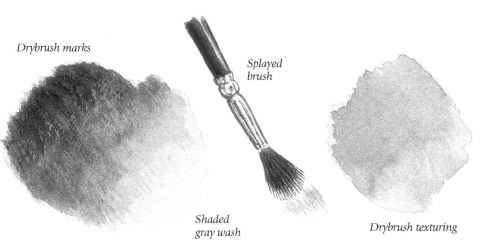

Drybrush marks

Splayed brush

Shaded gray wash

Drybrush texturing

WATERBIRDS

How to Drybrush

Fill a round brush with the appropriate color for the area you are working on. Blot the brush thoroughly on a paper towel. Splay the hairs apart at the tip and stoke over the area in the direction the feathers would lay. The more the area is drybrushed, the darker and more textured it will become. Be careful not to overwork it.

6 Add Final Details

The shadow areas of the head, back, wings and belly are drybrushed (see the "How to Drybrush" illustration above) to give them texture. Use Step 5 as a close-up reference for finishing the head.

Use the finished painting on page 100 for a visual reference of the wing and leg area. The legs are not drybrushed. The shadows are stroked into place using two steps. First, use rose mixture (F) for the rosy shadows. Let it dry. Apply rose mixture (G) for the dark shadows. Paint the claws with Payne's Gray.

Use layered washes of the grays and rose mixture (G) to form the rocks. To paint the wash around the breast and head, apply a pale version of rose mixture (G) to a damp surface.

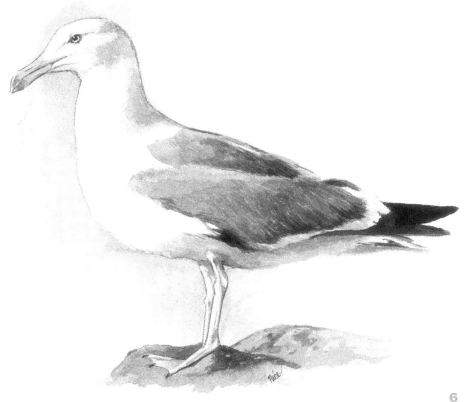

6

Emperor Penguin

KAY SMITH

MEDIUM: *Watercolor*

COLORS: **Da Vinci:** *Alizarin Crimson* • *Phthalo Green* • *Gamboge Hue* • *Titanium White* • *Ultramarine B* • **Holbein:** *Manganese Blue*

BRUSHES: **Pro Arte Prolene:** *no. 2 rigger* • **CJAS Golden Fleece:** *no. 8 round*

OTHER SUPPLIES: *140-lb. (300gsm) cold-pressed Saunders Waterford watercolor paper* • *no. 2 pencil* • *paper towel*

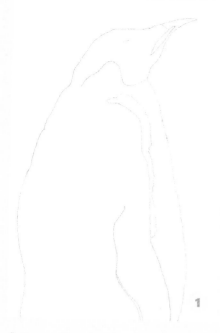

1

2

3

4

1 Create Sketch

Draw the outline of the bird's large shapes with a no. 2 pencil on water-color paper.

2 Basecoat Darks

For a black basecoat, mix two transparent colors: Alizarin Crimson + Phthalo Green (1:1). Wet paper front and back until flat, then blot with paper towel. Paint the head area (excluding the beak) with the black mixture on a no. 8 round, then lay in the vertical feather strip by the bird's shoulder. Note that the eye is dark and not easily seen. Applying wet paint directly to wet paper (wet-into-wet) allows you to create free-flowing washes of color.

3 Basecoat Darks

Add a small amount Manganese Blue to the black on the palette. Load the brush and paint the bird's back and flipper, leaving a white strip on the outside edge. Let dry.

4 Paint Beak, Neck, Breast

On dry paper, using thinned black, start at the tip of the beak with a no. 8 round or no. 2 rigger. Leave the orange-yellow area to paint later when the black is dry.

For the neck and breast, mix an orange color with Gamboge + Alizarin Crimson (1:1). With a no. 8 round and clean water, wet the white paper on the neck and breast area. Lay in orange with a strong value at the neck. Add thinned Gamboge under the orange and continue down the penguin's breast. Add very thin Manganese Blue at the bottom of the penguin's breast to show bouncing light from the snow. Use orange and paint the side of the beak with a no. 2 rigger. Let dry.

5 Paint Snow

(See the finished painting on page 104.) Wet the dry, white paper all around the bird with clean water and a no. 12 round. Blot slightly with a paper towel. Mix a thin wash of blues—Manganese and Ultramarine—and lay in the cool, snowy area behind and in front of the bird.

To make snowflakes, heavily load a no. 8 round with Titanium White. (Practice on scrap paper first.) Tap the brush against your left forefinger at an angle on dry paper. Specks of paint will appear as splattered flakes.

Check any areas for color or value adjustments. Lightly glaze the white flipper strip with very thin Manganese.

artist's comment

Mixing two granulating pigments—such as Ultramarine Blue and Manganese Blue—together in a thin wash makes an exciting texture.

Exotic Birds

The bright plumage of an exotic bird is always pleasing to the eye. In this section, you'll learn how to paint with colored pencil and embellish a watercolor painting with ink.

Cockatiel

GARY GREENE

MEDIUM: *Colored pencil*

COLORS: **Sanford Prismacolor:** *Deco Yellow • Pink Rose • Cool Grey 10 percent, 20 percent, 30 percent, 50 percent, 70 percent, 90 percent • Black • Cream • Pumpkin Orange • Pale Vermilion • Jasmine • Nectar • **Faber-Castell Polychromos:** Light Yellow Ochre*

BRUSHES: *Small, round watercolor brush*

OTHER SUPPLIES: *Three-ply Strathmore Vellum Bristol (regular surface) • electric pencil sharpener • Sakura electric eraser with white vinyl eraser strip • Prismacolor Tuffilm Final Fixative (matte finish)*

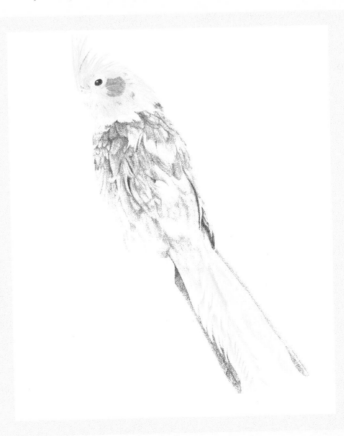

1

2

1 Draw the Layout

Draw layout lines with Deco Yellow, Cool Grey 30 percent and Pink Rose, as shown. The lines shown in this example layout are heavy for clarity only. Always draw your actual layout lines as lightly as possible.

2 Paint the Head

Lightly apply Cool Grey 70 percent, 50 percent and 30 percent to the gray head feathers using short, linear strokes. Lightly apply Light Yellow Ochre, Deco Yellow and Cream to the yellow head feathers using short, linear strokes. Lightly apply Pumpkin Orange and Pale Vermilion to the red-orange ear marking.

artist's comment

Keep your pencil points extremely sharp at all times. Apply the colors in the sequence described.

Cockatiel

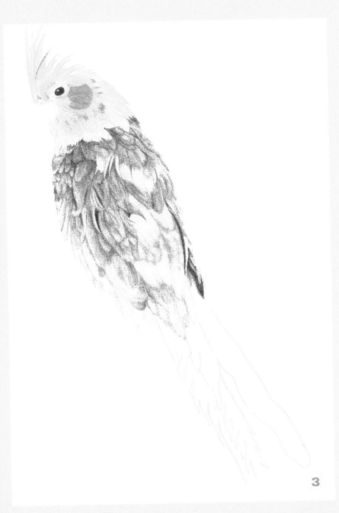

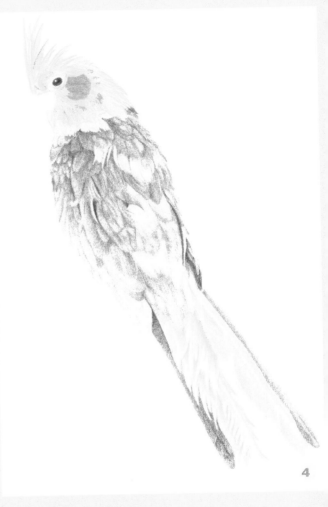

3 Paint the Body and Wings

Using short, linear strokes apply Cool Grey 90 percent, 70 percent, 50 percent, 30 percent, 20 percent and Cream to the body and wing feathers.

4 Paint the Tail Feathers

Using linear strokes, apply Cool Grey 90 percent, 70 percent, 50 percent, 30 percent, 20 percent, 10 percent, Jasmine and Cream to the tail feathers, as shown.

5 Paint the Beak and Foot
Apply Nectar, Pink Rose and Cool Grey 10 percent to the beak and foot. Finish with Prismacolor Final Fixative, Matte.

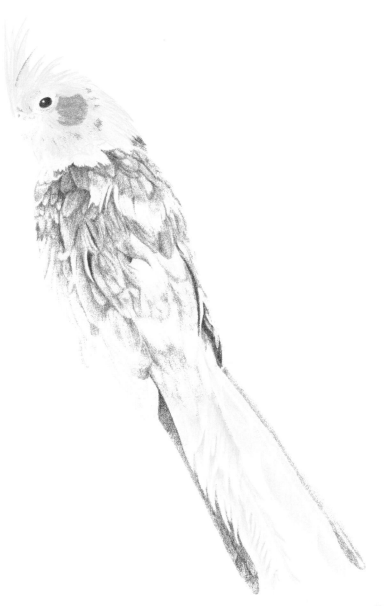

5

Red Macaw

CLAUDIA NICE

MEDIUM: *Watercolor*

COLORS: ***M. Graham & Co. Watercolor:*** *Cadmium Red Light • Payne's Gray • Cobalt Blue • Cadmium Yellow • Sap Green • Burnt Sienna*

BRUSHES: *Watercolor sable: nos. 3 and 6 round (Use the large brush to paint large areas and the small brush to paint smaller areas.)*

OTHER SUPPLIES: *140-lb. (300gsm) cold-pressed watercolor paper (artist grade) • pencil • paper towel*

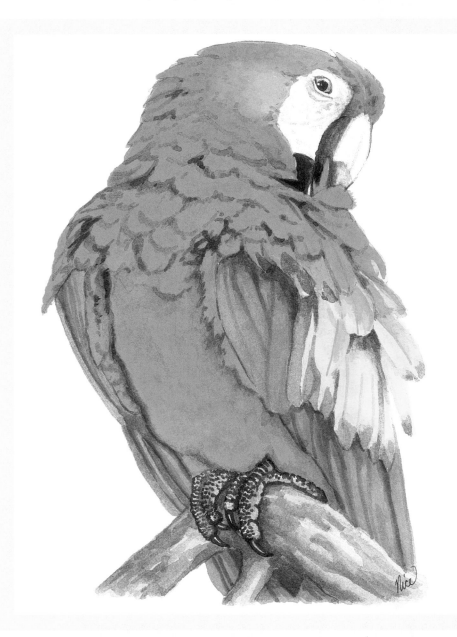

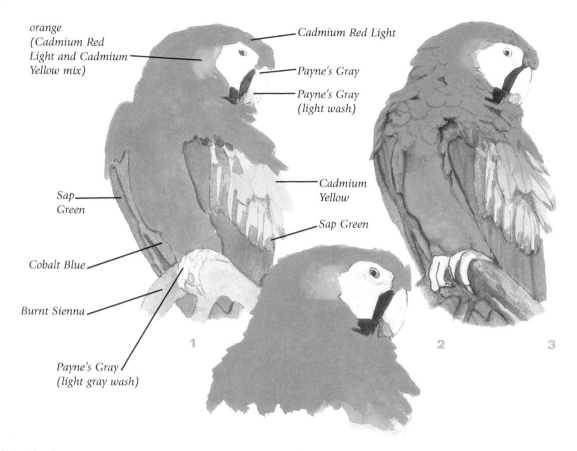

orange
(Cadmium Red
Light and Cadmium
Yellow mix)

Cadmium Red Light

Payne's Gray

Payne's Gray
(light wash)

Cadmium
Yellow

Sap
Green

Sap Green

Cobalt Blue

Burnt Sienna

Payne's Gray
(light gray wash)

1 2 3

1 Apply the Basecoat

Draw the macaw with a pencil. Paint the colors in the appropriate areas as shown, using washes (pigment and water mixtures that are thin and flow readily). Wet each area before applying the first wash and blot the extra water with a paper towel so that the surface is just damp. Work quickly to allow the paint to cover the area in a smooth, flat wash. Let each area dry before painting the one next to it.

You'll probably need to apply more than one coat of paint to the larger areas to achieve bright, intense color. Allow each layer to dry between applications. Once an area has been basecoated, you don't need to pre-moisten it before adding a new layer of paint.

2 Paint Eye, Beak and Face

Paint the iris with a light wash of Payne's Gray, leaving a white highlight dot above the pupil and a smaller one to the left of it. Paint the pupil using dark Payne's Gray. Paint the details on the beak and face using a mix of Payne's Gray with Burnt Sienna added to warm it. (The paint should be thinned to a wash consistency.) Use the tip of the smaller brush to create the dots.

3 Shade and Detail Feathers

Use a mixture of Cadmium Red Light and Sap Green to create a shadow hue for the red feathers. Outline the bottom of each feather using either brush, then shade the breast. Use a clean, damp brush to soften the edges of the darker paint, especially on the breast area.

Glaze a blush of thinned Cadmium Red Light over the upper yellow feathers. Paint the feather shafts on the wing Cadmium Red Light. Detail the blue feathers with a mixture of Cobalt Blue and Payne's Gray. Paint the shadows in the green areas using Sap Green darkened with a touch of Cadmium Red Light.

4 Detail Feet and Branch

(See the finished painting on page 110.) Detail the feet with Payne's Gray using the smaller brush. Use the tip of the brush to stipple the dots. When the paint is almost dry, stroke it lightly with a damp brush to soften the dots just a little. Do not overstroke.

Texture the branch by painting lines using several mixtures of Burnt Sienna and Sap Green. While the paint is still moist, soften the edges of the lines by stroking it with a clean, damp brush.

Peacock

CLAUDIA NICE

MEDIUM: *Pen, ink and watercolor*

COLORS: **M. Graham & Co. Watercolor:** *Phthalocyanine Green • Phthalocyanine Blue • Cadmium Red Light • Payne's Gray* **Winsor & Newton:** *Lemon Yellow • Indanthrene Blue*

BRUSHES: **Sable watercolor brush:** *no.6 round •* **Round detail brush:** *no. 1 or 2 (Use the larger brush in all the areas except where fine lines are needed.)*

OTHER SUPPLIES: *140-lb. (300gsm) cold-pressed watercolor paper (artist grade) • Koh-I-Noor Rapidograph pen (.30mm) or Sakura Pigma Micron Pens in black, brown and blue (005 nib) • Daler-Rowney Artist Color Inks in Indigo and Burnt Umber, if using a Rapidograph pen • pencil*

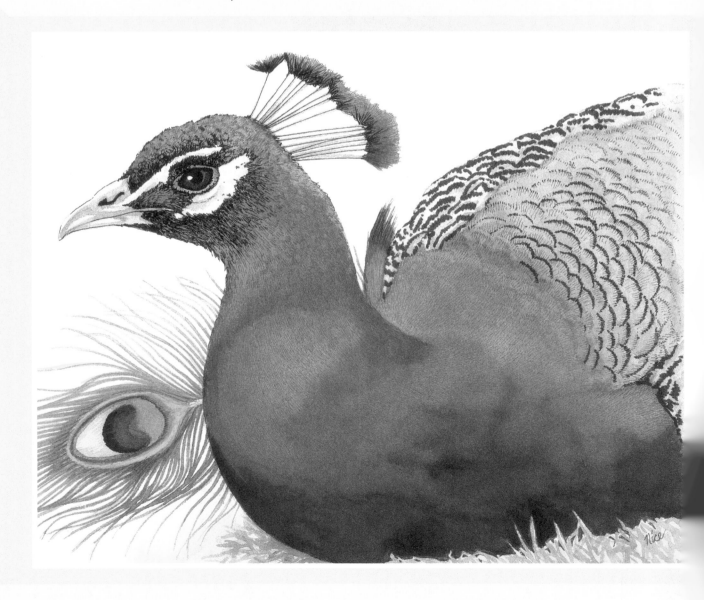

Color References

In this demonstration, colors and color mixtures are identified by a letter. Refer to this chart to find the correct color.

A. Phthalocyanine Green

B. A blend of (A) and (C)

C. Phthalocyanine Blue

D. A blend of (C) and (E)

E. Indanthrene Blue

F. Indanthrene Blue/Payne's Gray

G. Phthalocyanine Blue/Cadmium Red Light

H. Mix orange (Lemon Yellow/Cadmium Red Light) with a touch of Phthalocyanine Blue

I. Varied mixtures of Lemon Yellow and Phthalocyanine Green

Inks

Indigo

Burnt Umber

1 Draw Bird and Apply Ink

Draw the peacock and feathers in pencil.

Using black ink, stroke in the crisscross lines on the head and crest as shown. Form the ink lines into crescent shapes across the back. Refer to the inking diagram (left). Fill in the pupil of the eye solidly, leaving a white highlight dot. Using brown ink, fill in the iris of the eye and the squiggly lines on the wings. (Be sure to clean the pen between ink colors.)

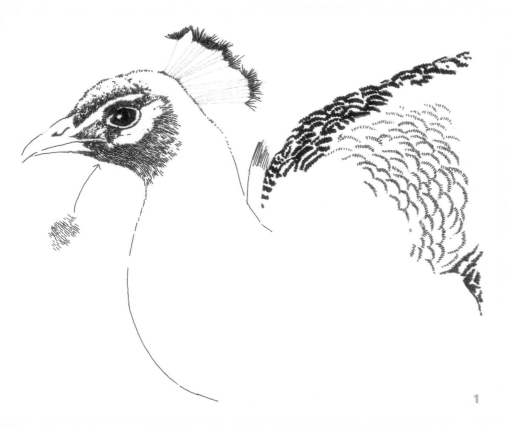

1

113

Peacock

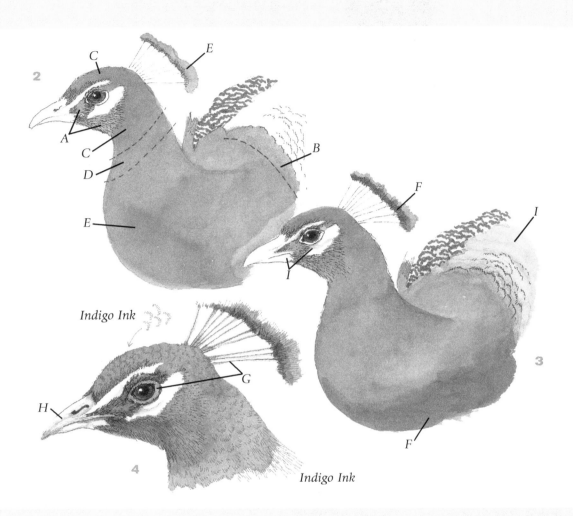

Indigo Ink

Indigo Ink

2 Apply Basecolors

Paint the body and the crest of the bird with bright washes of watercolor. (Washes are fluid mixtures of paint and water.) Premix all the colors that will be needed on your palette. Wet the areas to be painted and blot off the excess moisture. Paint the green patch on both sides of the eye and the chin color (A). Blot the tip of the brush each time you dip it in paint and work with minimum strokes. Before the first paint is dry, apply paint color (C) to the crown, the back of the head and upper neck. Allow the paint colors to mingle and blend together naturally where they meet in all the areas of Step 2. You must work quickly in order for this to happen.

Next, paint the strip through the neck with color mixture (D). Paint the chest and lower back with (E). Dampen this larger area before starting if it has dried. Spread the paint quickly and don't overstroke it. Paint the crest feathers with (E). Stroke the lower edge of the back with mixture (B).

3 Apply Green Glazes

Use green mixtures (I) to paint the upper back, working toward the lightest yellow-green at the highest point. Blend from one shade into the next. Shade the lower beak and the shadow in the white area below the eye with the lightest mixture (I). Glaze a thin layer of mixture (F) over the lower chest, the neck ridge, and the lower part of the crest feathers to shade them. Blend the edges with a clean, damp brush. Clean it after every few strokes.

4 Detail Beak and Eye

Use mixture (H) to shade the beak, leaving white highlights. You do not need to pre-dampen these small areas. The small er round brush will be useful for painting the areas in this step. Paint around the eye and outline the quills of the crest with mixture (G).

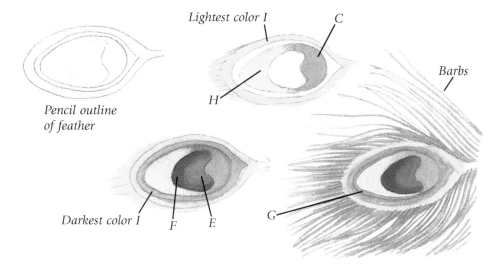

Pencil outline
of feather

Lightest color I

C

H

Barbs

Darkest color I

F E

G

Begin with a pencil outline and paint the areas as shown in the diagram at left.

Paint the elements using the indicated colors. It is not necessary to pre-dampen these areas. Let each area dry before painting the color next to it.

Use the small brush to stroke in the barbs and to paint the narrow patches. Add a touch of Cadmium Red Light to the darkest green mix (I) to make the deeper green color for the barbs.

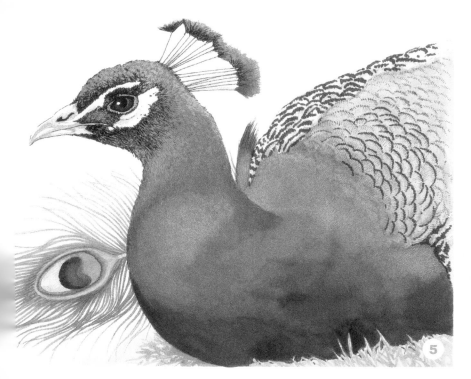

...ll the Rapidograph pen with Indigo ink and texture the blue areas of the peacock
...ith ink lines. (Also refer to the diagram in Step 4 for a visual reference.) Use tiny lines
...rmed into a crescent for the head and neck and crisscross lines for the body. Use larg-
crescent shapes on the upper back. Paint the grass with varied shades of (H) and (I).

EXOTIC BIRDS

Details

In this section, you'll learn how to paint elements that will help you create a full composition—individual feathers, eggs and a nest.

Robin's Nest

SHERRY C. NELSON

MEDIUM: *Oil*

COLORS: **Winsor & Newton Artists' Oil Colour:** *Ivory Black • Titanium White • Raw Sienna • Raw Umber • Sap Green • Burnt Sienna • French Ultramarine*

BRUSHES: **Sherry C. Nelson Red Sable:** *nos. 2 and 4 brights; no. 0 round*

OTHER SUPPLIES: *odorless thinner*

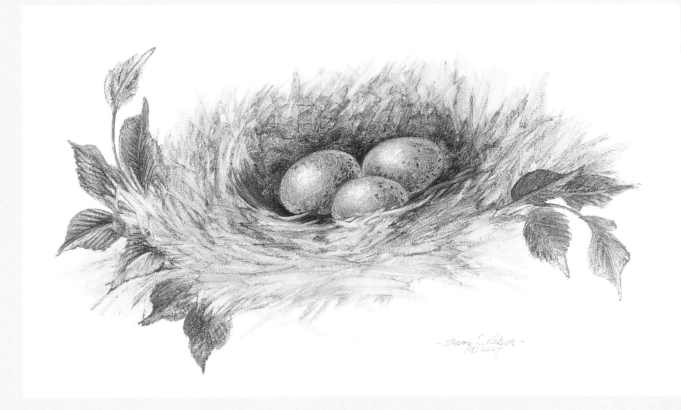

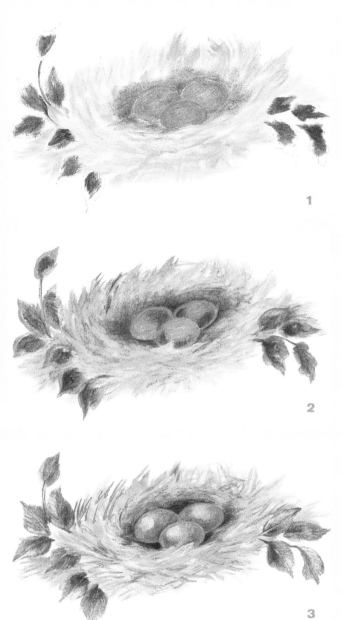

1 Apply Base Colors

Base the light-value area of the nest with chisel-edge strokes of sparse Raw Sienna, using either the no. 2 or no. 4 bright. Base the shadow area around the eggs with sparse Raw Umber.

Base the eggs with a brush-mix of French Ultramarine + Sap Green + Titanium White using the no. 2 bright. Base the dark-value area of the leaves with Ivory Black + Sap Green, again using the no. 2 bright.

2 Blend and Shade

Blend between the Raw Sienna and the Raw Umber within the nest using the chisel edge of the brush. Shade the Raw Umber areas with more Raw Umber, and blend the added dark just a bit into the Raw Sienna. Carry some Raw Umber shading into other areas of the nest for interest. Shade the eggs with Raw Umber. Base the light-value leaf areas with Sap Green + Raw Sienna + Titanium White.

3 Add Twigs, Blend

Load a little Raw Umber on the no. 4 bright, and tip the brush in a little odorless thinner to extend the paint slightly. Use this to add Raw Umber twigs here and there within the nest.

Blend the shading on the eggs and add Titanium White highlights. Blend the leaves following the lateral growth direction using the chisel edge of the no. 2 bright. Accent with Burnt Sienna.

4 Highlight

(See finished painting on page 116.) Lift out nest highlights with the no. 4 bright dampened with odorless thinner. When the leaves and eggs are complete, use the damp brush to pull nest twigs over the leaves and eggs to create the illusion of depth and to soften the overall look.

Blend highlights on the eggs, then detail with very thin Raw Umber using the no. 0 round. Blend accents in the leaves following the growth direction, then add veins with the chisel edge of a no. 2 bright.

artist's comment

In this demonstration, the "+" sign indicates brush-mixed colors. These mixes vary naturally and create a more realistic look than palette-knife mixes do. Continue using the same brush type and size in each area unless instructed to switch to a different size.

Wood Thrush Feather

SHERRY C. NELSON

MEDIUM: *Oil*

COLORS: **Winsor & Newton Artists' Oil Colour:** *Titanium White • Raw Sienna • Raw Umber • Sap Green*

BRUSHES: **Sherry C. Nelson Red Sable:** *nos. 2 and 4 brights • no. 0 round*

OTHER SUPPLIES: *odorless thinner*

1 Apply Base
Base the feather with Raw Sienna using the no. 2 or no. 4 bright.

2 Create Shape, Shade
Blend following the lateral growth direction of the feather to give it shape and form using the no. 4 bright. Shade with Raw Umber.

3 Blend Shading and Highlight
Using the chisel edge of the brush, blend the Raw Umber by following the growth direction. Highlight the upper half of the feather with Titanium White.

4 Add Final Details
Blend the highlight following the growth direction on the top side of the feather. Add a little accent color with Raw Umber + Sap Green, again blending according to the lateral growth direction.

Lift out splits in the feather with a brush dampened with odorless thinner. Thin a bit of Raw Sienna + Raw Umber + Titanium White. Use this brush mix on a no. 0 round to add a few frizzy down fibers at the base of the feather. Highlight the central area of the shaft with Titanium White.

artist's comment

In these two feather demonstrations, the "+" sign indicates brush-mixed colors. These mixes vary naturally and create a more realistic look than palette-knife mixes do. Continue using the same brush type and size in each area unless instructed to switch to a different size.

A trick for painting perfect feathers: Use a small brush that holds a perfect chisel edge or knife edge. Lay strokes on the feather side-by-side, very closely together, and slightly curving to create the natural meshlike fiber of the feather barbs.

Blue Jay Feather

SHERRY C. NELSON

MEDIUM: *Oil*

COLORS: ***Winsor & Newton Artists' Oil Colour:*** *Ivory Black • Titanium White • French Ultramarine • Raw Umber*

BRUSHES: ***Sherry C. Nelson Red Sable:*** *nos. 2 and 4 brights • no. 0 round*

OTHER SUPPLIES: *Cheesecloth • stylus • tracing paper • ballpoint pen*

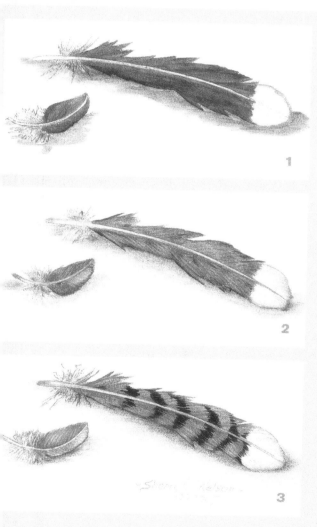

Start with the Shadows

Paint the shadow completely before you start painting the feather. Base the shadow with sparse Raw Umber, as shown in Step 1. Use a small piece of cheesecloth to softly rub the edges of the shadow to soften as shown in Step 2. Finally, shade next to the feathers with a bit of Raw Umber + Ivory Black to deepen the shadow. Soften with cheesecloth again if needed.

1 Outline and Base

Using the no. 2 bright, outline the tip of the large feather with a brush-mix of Titanium White + Ivory Black + Raw Umber. Base the dark blue areas of both feathers with French Ultramarine + Ivory Black. Use the same brush-mix very sparsely to base the downy base of the feather.

2 Develop Shape

Base the tip of the feather inside the blue outline with Titanium White using the chisel edge of the no. 4 bright. Then use the dirty brush to blend the feathers by pulling paint in the lateral growth direction from the shaft to give each feather the correct shape. Use the no. 2 bright on the small feather. Highlight the small feather with the dirty brush + Titanium White. Outline the tip of the shaft with a bit of the dark-blue brush-mix.

You can mark the patterns of the markings in the wet feather with a stylus, or by laying the tracing paper pattern on the painting. Draw over the pattern with a ballpoint pen, leaving the markings transferred into the wet paint as a guide.

3 Paint Markings

Add detail markings with a thinned brush-mix of Ivory Black + Raw Umber using the no. 0 round. Use Titanium White for the shaft of the feather, applying it with the chisel edge of the no. 4 bright. Thin a bit of Ivory Black + Titanium White + Raw Umber and place a few downy hairs at the base of the feathers using the no. 0 round.

DETAILS

119

Evening Grosbeak Feather

SHERRY C. NELSON

MEDIUM: *Oil*

COLORS: **Winsor & Newton Artists' Oil Colour:** *Ivory Black* • *Titanium White* • *Raw Sienna* • *Raw Umber* • *Sap Green* • *Cadmium Yellow Pale*

BRUSHES: **Sherry C. Nelson Red Sable:** *nos. 2 and 4 brights*

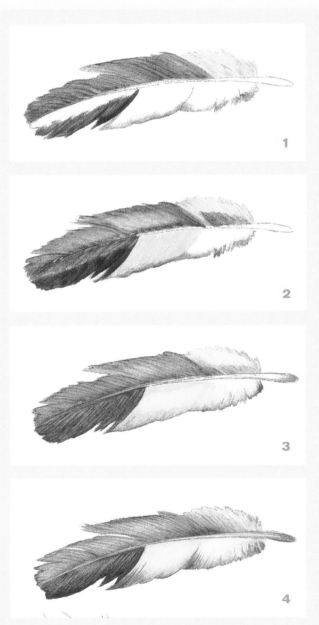

1 Apply Base

Using a no. 4 bright, base the dark area on the top half of the feather with Sap Green + Raw Umber. Base the light area with a dirty brush + Titanium White.

Base the dark area on the bottom half with Ivory Black + Raw Umber. Roughly outline the remainder of the feather with Raw Sienna + Sap Green.

2 Add Shading and Finish Base

Shade the light area on the top half with the dark brush-mix of Sap Green + Raw Umber. Highlight the dark area with Titanium White + Cadmium Yellow Pale + Raw Sienna.

On the bottom half, base the remainder of the dark area with Raw Umber. Base the remainder of the midsection with Titanium White + Cadmium Yellow Pale + Raw Sienna. Base the remainder of the feather with Titanium White.

3 Blend

On the top half, blend following the lateral growth direction of the feather using the no. 4 bright. Highlight the light area with Titanium White.

On the bottom half, blend each section separately with the chisel edge of the no. 4 bright. Highlight both the light area and the yellowish area with Titanium White. Outline the shaft tip with a bit of Raw Umber.

4 Blend and Highlight

Reblend the top half with the chisel edge of the brush, following the lateral growth direction and using very closely spaced brushstrokes.

Re-blend the bottom half, increasing the pressure on the brush in the dark area to lift some of the paint, and allowing the white undercoat to give a slight highlight. Use the chisel edge of the brush to add a little Titanium White to the shaft of the feather and clean up the brushstrokes within the shaft.

Green Jay Feather

SHERRY C. NELSON

MEDIUM: *Oil*

COLORS: **Winsor & Newton Artists' Oil Colour:** *French Ultramarine • Titanium White • Raw Sienna • Raw Umber • Cadmium Yellow Pale*

BRUSHES: **Sherry C. Nelson Red Sable:** *nos. 2 and 4 brights • no. 0 round*

OTHER SUPPLIES: *odorless thinner*

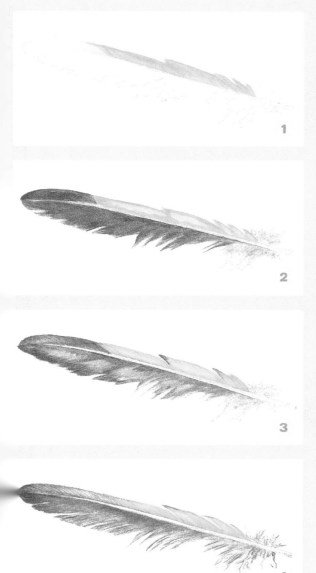

1 Apply Yellow Base

Base the yellow areas of the feather with a brush-mix of Cadmium Yellow Pale + Raw Sienna using the no. 2 bright.

2 Highlight and Apply Blue Base

Pick up some Titanium White on the dirty no. 2 bright and highlight the central area of the yellow base. Using the no. 4 bright, base the remainder of the feather with a brush-mix of French Ultramarine + Raw Umber + Raw Sienna, pulling paint in the lateral growth direction of the feather to begin giving it shape.

3 Add Details

Blend the yellow band following the lateral growth direction using the chisel edge of the no. 2 bright. Add a bit of the blue brush-mix for accent on the edge of the feather as shown.

Lay on a Titanium White highlight within the blue side of the feather using the no. 4 bright. Lift out the feather shaft with a brush dampened with odorless thinner if painting on white. Add Titanium White for the shaft of the feather otherwise.

4 Blend and Add Final Details

Blend accents on the yellow side of the feather following the growth direction. Blend highlights with growth on the blue side of the feather. Thin a bit of the blue base brush-mix and use a no 0 round to add a few frizzy down feathers at the base of the feather. Highlight the central area of the shaft with Titanium White.

artist's comment

A trick for painting perfect feathers: Use a small brush that holds a perfect chisel edge or knife edge. Lay strokes on the feather side-by-side, very closely together, and slightly curving to create the natural meshlike fiber of the feather barbs.

DETAILS

Eggs

SHERRY C. NELSON

MEDIUM: *Oil*

COLORS: **Winsor & Newton Artists' Oil Colour:** *Ivory Black • Titanium White • Raw Sienna • Raw Umber • Sap Green • Alizarin Crimson • French Ultramarine • Burnt Sienna*

BRUSHES: **Sherry C. Nelson Red Sable:** *nos. 2 and 4 brights • no. 0 round*

OTHER SUPPLIES: *Cheesecloth*

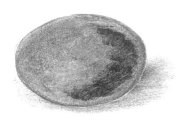 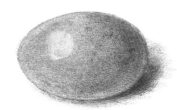 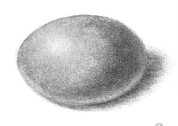

1 2 3

American Robin
1 Base
Base with a turquoise-like brush-mix of French Ultramarine + Sap Green + Titanium White using the no. 4 bright. Add a shadow crescent with Raw Umber.

2 Blend and Highlight
Blend Raw Umber into the basecoat where the shadow and basecoat meet. Highlight with a dirty brush + Titanium White.

3 Blend and Highlight
Blend the highlight where values meet. Highlight with additional Titanium White if needed.

1 2 3

Red-Breasted Nuthatch
1 Base
Base with Titanium White + Raw Umber + Raw Sienna using the no. 2 bright.

2 Shade and Highlight
Shade with Raw Umber. Highlight with Titanium White.

3 Add Markings
Using the no. 0 round brush, add detail markings with slightly thinned Burnt Sienna + Raw Umber.

1

2

3

Green Jay
1 Base
Paint the dark area with Titanium White + Sap Green + Raw Sienna. Paint the light area with a dirty brush + Titanium White using the no. 4 bright.

2 Accent and Highlight
Blend where the values meet. Accent with Raw Sienna. Highlight with Titanium White.

3 Add Markings
Add detail with slightly thinned Burnt Sienna + Raw Sienna using the no. 0 round brush.

1

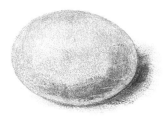

2

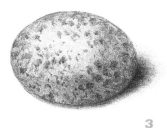

3

Scarlet Tanager
1 Base
Paint the dark area with Sap Green + French Ultramarine + Titanium White. Paint the light area is Titanium White using the no. 4 bright.

2 Shade and Highlight
Blend where the values meet. Shade with Burnt Sienna + Raw Sienna. Highlight with Titanium White.

3 Add Details
Detail with irregular spots of slightly thinned Burnt Sienna + Alizarin Crimson using the no. 0 round brush. Add a few spots of Raw Sienna.

artist's comment

All the painted eggs on these two pages have been enlarged to 150 percent of their actual size for ease of demonstration. When you use them in a design, paint them in proportion to the bird in the painting.

In these demonstrations, the "+" sign indicates brush-mixed colors. These mixes vary naturally and create a more realistic look than palette-knife mixes do. Continue using the same brush type and size in each area unless instructed to switch to a different size.

DETAILS

About the Artists

CINDY AGAN

Cindy Agan is a self-taught, internationally published watercolor and portrait artist, author and instructor. She prefers realism in all mediums, including watercolor pastel and acrylics. She is the author of a book and video titled *Painting Watercolors That Sparkle With Life* (North Light Books). An excerpt of her video has been included in the video *10 Top Painting Tips* with nine other artists from around the world. Her award-winning paintings have been featured in several publications, including North Light's best-of-watercolor *Splash* series Volumes 6, 7, 9 and 10; *Painter's Quick Reference: Cats & Dogs; A Celebration of Light: Painting the Textures of Light in Watercolor;* and *Drawing and Painting People: The Essential Guide.* Cindy's work has been displayed in numerous national and international juried shows, group and solo exhibits, and can be found in private and corporate collections. Cindy teaches workshops throughout the U.S. and Canada, is the recipient of over seventy awards, and is a signature member of the Louisiana Watercolor Society. Visit www.cindyaganart.com

GARY GREENE

In addition to being an accomplished fine artist, Gary Greene has been a professional artist since 1967. He's the author of nine North Light books and has produced six video workshops. He has contributed articles to *The Artist's Magazine,* and his colored pencil paintings have appeared in *American Artist* and *International Artist* magazines. Gary is a fourteen-year Signature Member of the Colored Pencil Society of America (CPSA) and has taught workshops nationally and internationally since 1985.

BARBARA LANZA

Barbara Lanza is the author of *Enchanting Fairies* (published by Impact Books) and *Time to Fly: A Fairy Lane Book.* She has also illustrated many children's books. She recently licensed her art for use on various products. She lives in Orange County, New York.

DAVID LEE

David Lee has been interested in drawing and painting since he was a child. He studied Chinese brush painting in his early years and lately has concentrated on western watercolor painting. He has won numerous awards and has been elected as a member of Allied Artists of America, New Jersey Watercolor Society, Knickerbocker Artists, American Artists Professional League and Hudson Valley Art Association. He has been featured in *The Artist's Magazine* and North Light's best-of-watercolor *Splash* series Volumes 6 and 8.

VICTORIA LISI

Victoria Lisi began illustrating book covers professionally in the early 1980s. Since then she has illustrated over two hundred book covers in various genres. She has also illustrated twelve children's picture books, and numerous puzzles and calendars. In recent years, she has turned to fine art, winning numerous local and regional awards in juried fine art exhibitions. Contact v.j.lisi@mindspring.com

JANE MADAY

Jane Maday has been a professional illustrator since she was fourteen years old. At age sixteen she became a scientific illustrator for the University of Florida. She worked for eight years as a greeting card artist for Hallmark Cards. Jane licenses her work for products such as greeting cards, puzzles, stitchery kits and T-shirts. She is the author of *Adorable Animals You Can Paint, Cute Country Animals You Can Paint* and *Landscapes in Bloom.* Visit www. janemadayart.com.

SHERRY C. NELSON

Sherry C. Nelson, Master Decorative Artist (MDA), teaches seminars and conventions worldwide. Her love and respect for the natural world is evident in her extensive field study, resulting in beautifully accurate and detailed depictions of its flora and fauna. Sherry has produced over twenty publications to date, including *Painting Songbirds With Sherry C. Nelson* (North Light).

CLAUDIA NICE

Claudia Nice attended the University of Kansas but gained her realistic pen, ink and watercolor techniques from sketching nature. A native of the Pacific Northwest, she spent more than fifteen years traveling across North America as an art consultant, conducting seminars, workshops and demonstrations. Claudia is the author of several North Light books, including *Creating Textures in Pen & Ink With Watercolor*, *Watercolor Made Simple with Claudia Nice* and *Creating Textured Landscapes with Pen, Ink and Watercolor*.

ELIZABETH GOLZ RUSH

Elizabeth Golz Rush has always loved to draw, paint and make things. Some of her happiest moments have been spent surrounded by the clutter of materials, engaged in creative projects. She loves color, pattern and the challenge of balancing accuracy with design. While nature is her first inspiration, she also loves rummaging through thrift shops, flea markets and libraries. Elizabeth grew up in California. In college she majored in printmaking and has a B.F.A. from California College of Art and Crafts and an M.F.A. from Cranbrook Academy of Art. Her work experience is diverse and includes teaching and serving as an art director and in-house designer. Currently self-employed, she licenses her designs to select companies, focusing on giftware, textile and paper products. Elizabeth lives in Concord, Massachusetts.

KAY SMITH

A frequently published watercolorist since 1993, Kay Smith has attained national attention for her vibrant, colorful designs. A signature member of Southwestern (Texas) and Wyoming Watercolor Societies, she maintains her studio gallery in Big Spring, Texas. Visit www.kaysmithbrushworks.us.

LIAN QUAN ZHEN

Lian Quan Zhen teaches Chinese and watercolor painting workshops internationally. His paintings hang in numerous institutional and private collections, including the MIT Museum, which has collected fourteen of his paintings. He has published two titles with North Light Books: *Chinese Painting Techniques for Exquisite Watercolors* and *Chinese Watercolor Techniques: Painting Animals*.

Resources

American Journey
(See Cheap Joe's Art Stuff)

Arches
(See Canson)

Cheap Joe's Art Stuff
Boone, NC
(800) 227-2788
www.cheapjoes.com

Chinese painting supplies
(See Zhen Studio)

ColArt Americas Inc.
Piscataway, NJ
(888) 422-7954
www.liquitex.com

Canson
www.canson-us.com

Daler-Rowney USA Ltd.
Cranbury, NJ
(609) 655-5252
www.daler-rowney.com

Daniel Smith, Inc.
Seattle, WA
(800) 426-6740
www.danielsmith.com

Da Vinci Paint Co.
Irvine, CA
(800) 553-8755
www.davincipaints.com

Derwent
Keswick, England
Tel: +44 (0) 17687 80898
www.pencils.co.uk

Dick Blick Art Materials
Galesburg, IL
(800) 828-4548
www.dickblick.com

Faber-Castell USA, Inc.
Cleveland, OH
(800) 642-2288
www.faber-castell.us

Gamblin Artists Colors Co.
Portland, OR
(502) 235-1945
www.gamblincolors.com

Golden Artist Colors, Inc.
New Berlin, NY
(800) 959-6543
www.goldenpaints.com

Golden Fleece
(See Cheap Joe's Art Stuff)

Grumbacher
www.grumbacherart.com

Holbein Works, Ltd.
www.holbein-works.co.jp

Isabey
(See Cheap Joe's Art Stuff or
Dick Blick Art Materials)

Iwata Medea Inc.
Portland, OR
(503) 253-7308
www.iwata-medea.com

Jack Richeson & Co., Inc.
Kimberly, WI
(800) 233-2404
www.richesonart.com

Koh-I-Noor
Czech Republic
www.koh-i-noor.cz

Liquitex
(See ColArt Americas, Inc.)

Loew-Cornell, Inc.
Englewood Cliffs, NJ
(201) 836-7070
www.loew-cornell.com

M. Graham & Co.
West Linn, OR
(503) 656-6761
www.mgraham.com

Martin/F. Weber Company
Philadelphia, PA
(215) 677-5600
www.weberart.com

Masquepen
(800) 947-1389
www.masquepen.com

Masterson Art Products
Phoenix, AZ
(800) 965-2675
www.mastersonart.com

Plaid
(800) 842-4197
www.plaidonline.com

Prismacolor
(See Sanford Brands)

Pro Arte brushes
Skipton, England
www.proarte.co.uk

Robert Simmons brushes
(See Daler-Rowney USA
Ltd.)

Royal Talens B.V.
The Netherlands
Tel: +31 (55) 527 4700
www.talens.com

Sakura
Hayward, CA
www.sakuraofamerica.com/

Sanford Brands
(800) 323-0749
www.sanford.com
www.grumbacherart.com
www.prismacolor.com

Saral Paper Corp.
New York, NY
(212) 223-3322
www.saralpaper.com

Schmincke
(See Cheap Joe's Art Stuff or
Dick Blick Art Materials)

Sherry C. Nelson brushes
www.sherrycnelson.com

Silver Brush Limited
Windsor, NJ
www.silverbrush.com

Staedtler
(800) 776-5544
www.staedtler-usa.com

Strathmore Artist Papers
Westfield, MA
www.strathmoreartist.com

Sumi Ink
(See Cheap Joe's Art Stuff or
Dick Blick Art Materials)

Van Gogh
(See Royal Talens B.V.)

Winsor & Newton
www.winsornewton.com

Zhen Studio
P.O. Box 33142
Reno, NV 89533
lianzhen@yahoo.com
(Send a letter or an e-mail
with your inquiry.)

Index

Acrylic demonstrations, 24-25, 28-29, 30-31, 58-59, 64-67, 78-81, 92-95, 96-99
Antennae, 9, 19, 22, 31

Back, 101-103, 105
Background, 13, 22
 dappled, 81
 defining shape of bird with, 73
 sky, 85
 with white subject, 97
Basecoating, 25, 27, 29, 31, 47, 49, 69, 83, 91, 105, 111
Beak, 59, 72, 76, 79, 81, 83, 85, 87, 89, 91, 101-102, 105, 109, 111, 114
Belly, 72, 91, 93, 101, 103
Bill, 94, 97-98
Birds
 black-capped chickadee, 90-91
 bluebirds, 71-73
 blue jay, 78-81
 cardinal, 74-77
 cockatiel, 106-109
 egret, 96-99
 emperor penguin, 104-105
 goldfinch, 54-57, 58-59
 house sparrow, 84-85, 86-87
 hummingbird, 60-63, 64-67, 68-70
 mallard duck, 92-95
 mockingbird, 80-81
 painted bunting, 82-83
 peacock, 112-115
 red macaw, 110-111
 seagull, 100-103
 wren, 88-89
Blending, 15, 18, 117
 and highlighting, 27, 33, 47, 49, 120
 See also Edges, softening
Bodies
 bird, 61, 63, 66-67, 76, 108
 butterfly, 9, 19, 25, 27, 29
 See also Back, Belly, Breast
Branches, 76, 79, 87, 91, 111
Breast, 85, 87, 91, 105, 114

Brush
 chisel edge, 33, 47, 117, 118, 121
 dirty, 33, 49
Brush marks, splayed, 76-77
Brush-mixing, 27, 33, 47, 49, 117-119, 123
Butterflies
 alfalfa, 28-29
 cabbage, 30-31
 common blue, 24-25
 giant swallowtail, 6-9, 10-13, 14-15
 heliconius anderida, 20-23
 morpho, 34-37
 mourning cloak, 16-19
 painted lady, 42-45
 peacock, 38-41
 silvery blue, 26-27
 southern dogface, 32-33

Chinese watercolor, 60-63, 71-73, 86-87
Color, building up, 59
Colored pencil demonstrations, 6-9, 16-19, 106-109
Columbine, 69-70

Drybrushing, 15, 35-36, 44-45, 55, 80, 89, 93, 98, 103
Ducks. See Birds

Edges, softening, 15, 45, 91, 93
Eggs, 117, 122-123
Eye, 9, 73, 76, 79, 81, 83, 85, 87, 91, 97, 98, 101-102, 111, 113
Eye ring, 69
Eye spots, 53

Face, 72, 111
Feathers, 70, 72, 79, 81, 85, 87, 89, 93, 94, 111, 115
 blending, 77
 detailed, 118-121
 drybrushing, 55
 tail, 62, 87, 89, 91, 101-102, 108
 technique for, 59

Feet, 59, 63, 73, 76, 85, 87, 109, 111
Flowers, 23

Glazing, 11, 15, 21, 25, 36-37, 44, 55, 65-67, 75-77, 89, 91, 94-95, 102, 114
 See also Washes

Head, 61-62, 77, 85, 87, 89, 91, 93, 101, 103, 107, 114
 See also Beak, Bill, Eye, Face, Neck
Highlighting, 27, 33, 47, 49, 94, 117
 See also Blending, and highlighting

Layout lines, 7, 17, 106
Leaves, 22-23, 27, 56
Legs, 79, 83, 85, 91, 101

Masking fluid, 55
 applying, 43, 65, 75, 93
 protecting brush from damage, 11, 21, 29
 removing, 13, 23, 45, 57
Moths
 geometrid, 46-47
 noctuid, 48-49
 sphynx, 50-53
Mouth. See Beak, Bill

Neck, 101, 105, 114
Nest, 116-117

Oil demonstrations, 26-27, 32-33, 46-47, 48-49, 68-70, 116-123
Outlining, 35

Paint
 brush-mixing, 27, 33, 47, 49, 117-119, 123
 difference between brands, 43
 mixing dark, neutral tones, 65
 thinned, 29, 31
Painting, light to dark, 80

Pen, ink and watercolor demonstration, 112-115
Pencil drawing, 51, 65, 75, 77

Shadows, 119
Sketch, 101
 composing and transferring, 11, 21, 39, 55, 81, 89, 93
 detailed, 35
 See also Pencil drawings
Snow, 105
Stomach. See Belly
Sunflower, 88-89

Tail. See Feathers, tail
Texture, creating, 52, 98
Tinting, 39-40, 51-52

Underpainting, 17, 66, 75, 77, 93-94

Values
 dark, 18
 deepening, 15, 35
 varied range, 93, 97

Washes, 79, 81, 88-89, 101-102, 111, 114
Watercolor demonstrations, 10-13, 14-15, 20-23, 34-37, 38-41, 42-45, 50-53, 54-57, 74-77, 80-81, 82-83, 84-85, 88-89, 90-91, 100-103, 104-105, 110-111
 Chinese, 60-63, 71-73, 86-87
 See also Pen, ink and watercolor demonstration
Wet-into-wet, 93-94, 105
Wet-on-dry, 93
Wings
 bird, 61-62, 66-67, 73, 81, 83, 85, 87, 89, 91, 101-103, 108
 butterfly, 7-9, 12, 15, 17-19, 25, 29, 31, 35-37, 39-41, 43-45
 moth, 47, 51-52
 See also Feathers

CPSIA information can be obtained
at www.ICGtesting.com
Printed in the USA
BVHW010821190122
626616BV00010B/125